MW01077488

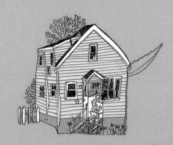
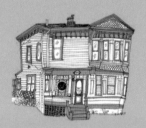
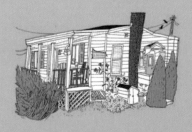
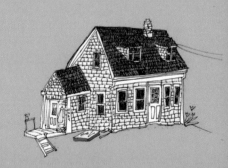

HAND DRAWN HALIFAX

PORTRAITS OF THE CITY'S BUILDINGS, LANDMARKS, NEIGHBOURHOODS, AND RESIDENTS

EMMA FITZGERALD

FORMAC PUBLISHING COMPANY LIMITED
HALIFAX

Dedicated to the memory of my two grandmothers, Noreen Meagher (Nana) and Margaret FitzGerald (Granny), and my aunt, June Culliton, who told me I would one day write a book.

Copyright © 2015 by Emma FitzGerald

All rights reserved. No part of this book may be reproduced or transmitted in any form or by any means, electronic or mechanical, including photocopying, or by any information storage or retrieval system, without permission in writing from the publisher.

Formac Publishing Company Limited recognizes the support of the Province of Nova Scotia through the Department of Communities, Culture and Heritage. We are pleased to work in partnership with the province to develop and promote our culture resources for all Nova Scotians. We acknowledge the support of the Canada Council for the Arts for our publishing program.

 FILM & CREATIVE INDUSTRIES NOVA SCOTIA The Canada Council for the Arts | Le Conseil des Arts du Canada Canadä

Design: Meghan Collins & Meredith Bangay

Library and Archives Canada Cataloguing in Publication

FitzGerald, Emma, 1982-, author, illustrator
 Hand drawn Halifax : portraits of the city's buildings, landmarks, neighbourhoods and residents / Emma Fitzgerald.

ISBN 978-1-4595-0397-7 (bound)

 1. Halifax (N.S.)--Pictorial works.
2. Halifax (N.S.)--Biography.
I. Title.

FC2346.37.F57 2015 971.6'22050222 C2015-903634-8

Formac Publishing Company Limited
5502 Atlantic Street
Halifax, Nova Scotia, Canada
B3H 1G4
www.formac.ca

Printed and bound in China

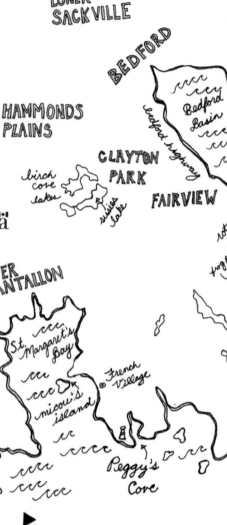

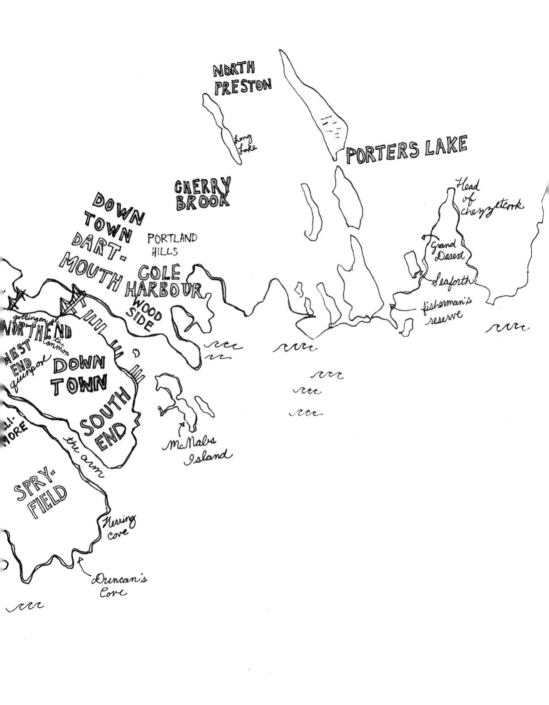

INTRODUCTION

I moved to Halifax eleven years ago. Over the years, Halifax became a place where the fabric of life is woven with a warmth that gives it an undeniable sense of "home." Halifax has an ebb and flow as strong as the Atlantic Ocean. People migrate for work and the city's buildings are under constant renovation. Amongst these changes are fixed institutions: people, events or buildings. I learned that a corner store can be a place to seek counsel and a church a place to enjoy some of the world's finest indie music. The drawings and stories found on these pages are an effort to bring attention to these vital parts of daily life in Halifax. I began in my North End neighbourhood, sitting on the side of the street and drawing what was in front of me with pen on letter-sized paper. In what became a wonderful ritual, I expanded farther to surrounding neighbourhoods, eventually drawing as far as Seaforth and St. Margarets Bay. I would set off on foot or by bus to new places and chat with new acquaintances, completing three or four drawings in a day. Upon my return home, I added colour. What unfolded is what you find in this book. I acknowledge it is not an exact history, but rather my direct experience of people and places. My lens is often rose-coloured, but my drawings bear witness; I hope to instigate conversation about what matters most to citizens of Halifax. I also hope that visitors, on opening the pages, feel that they are back in Halifax, for a moment.

I would like to thank all the many people who made this project possible. It showed me that with some curiosity there is much to see.

Michael Armstrong, also known as "12," was in a coma for three months and told he would never walk again after an accident. Instead, he has walked the streets of Halifax daily for sixteen years, from 8:30 a.m. to 10 p.m. some days, selling roses to early morning coffee drinkers at Steve-o-Reno's during the day and restaurant patrons at night. Always dressed to the nines, he is friendly and willing to chat — even if you don't buy a rose.

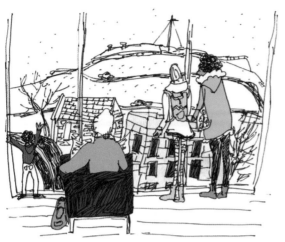

"This wasn't here before!!" says someone in disbelief as she approaches Spring Garden Road while home for Christmas. Indeed, the new Halifax Central Library is a stunning surprise, just a stone's throw from its former location, and designed by Danish architecture firm Schmidt Hammer Lassen. The library was designed to resemble a stack of books piled high, but as we are into the Christmas season I can't help thinking it looks like a stack of gifts. It is a great gift to the city of Halifax after all.

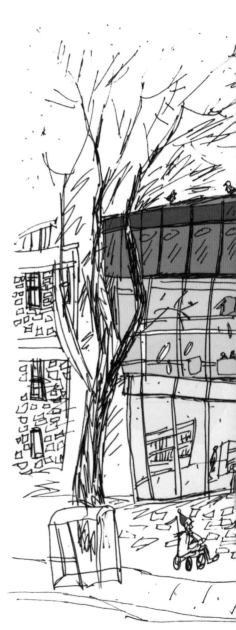

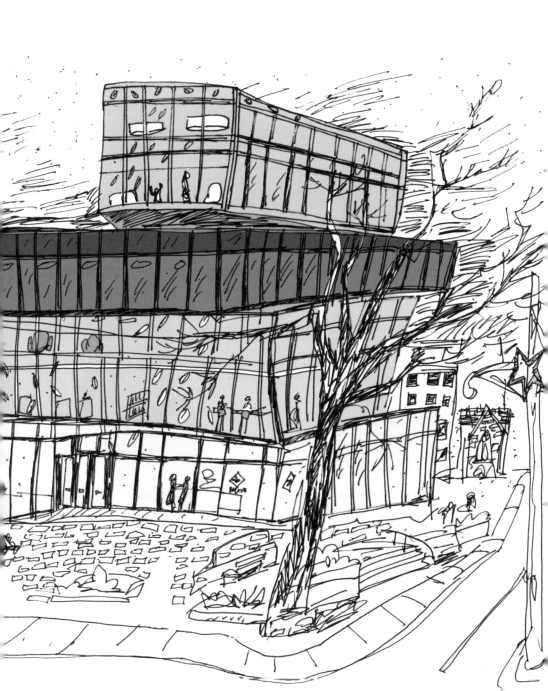

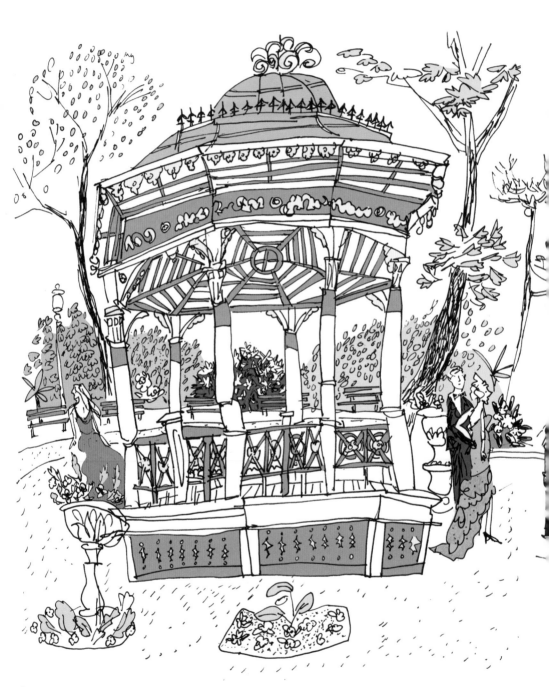

Prom season in the Public Gardens.
One month later, on Kijiji: "Prom dress
for $200, only worn for 3 hours."

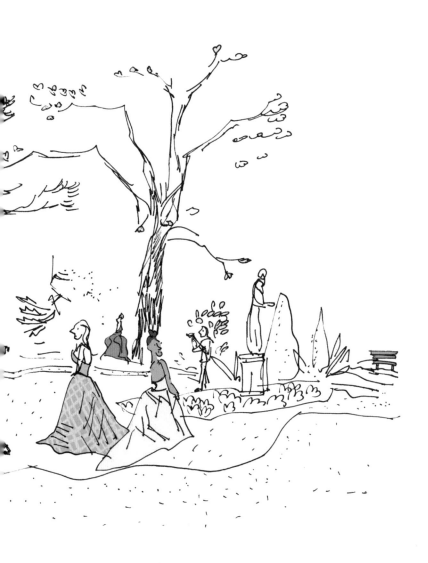

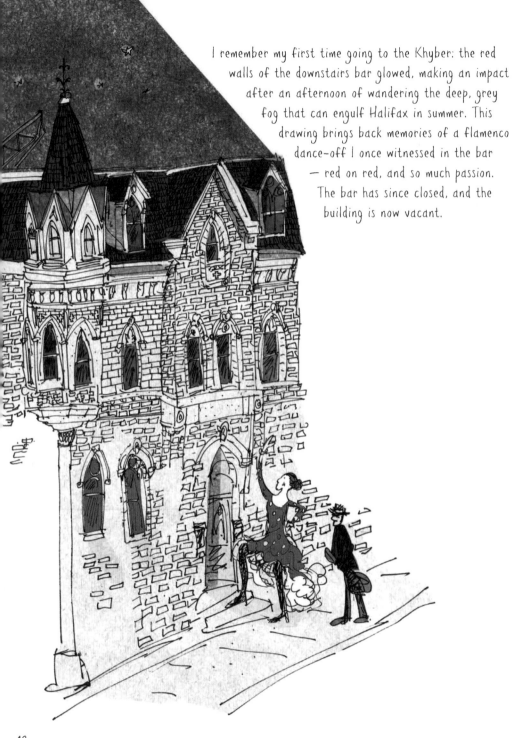

I remember my first time going to the Khyber: the red walls of the downstairs bar glowed, making an impact after an afternoon of wandering the deep, grey fog that can engulf Halifax in summer. This drawing brings back memories of a flamenco dance-off I once witnessed in the bar — red on red, and so much passion. The bar has since closed, and the building is now vacant.

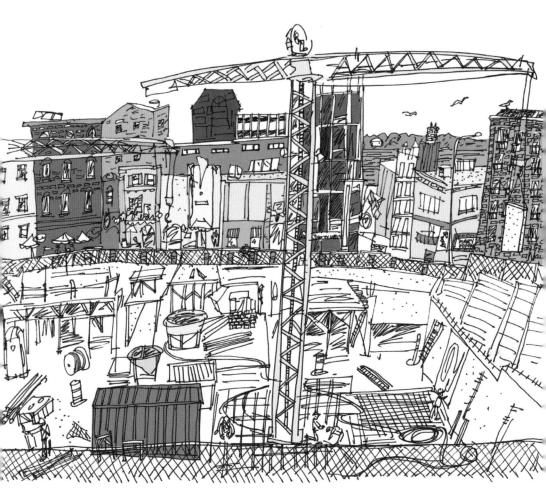

"Boyfriend? Boyfriend?" cried out the man in the taxicab idling beside me as I drew the construction site for the new Halifax Convention Centre, and I ignored him. Then I realized he was saying: "Portrait? Portrait?"

I turned and said, "yes, a building portrait." Through the window of his vehicle he handed me a clipboard with papers that contained sketches. They were mostly of buildings, made of stone. He was from Iran, and was drawing his village from memory while he waited for clients. He was glad to learn where he could find drawing classes, and then was off to drive Halifax town while thinking about his homeland.

St. Matthew's United Church is a heart for the city in many ways — concert venue, out of the cold emergency shelter, circus school, samba practice venue, and place of worship. Across the street is Halifax's Old Burying Ground, founded in 1749, where you are now likely to hear camera clicks and discussion from visiting history buffs.

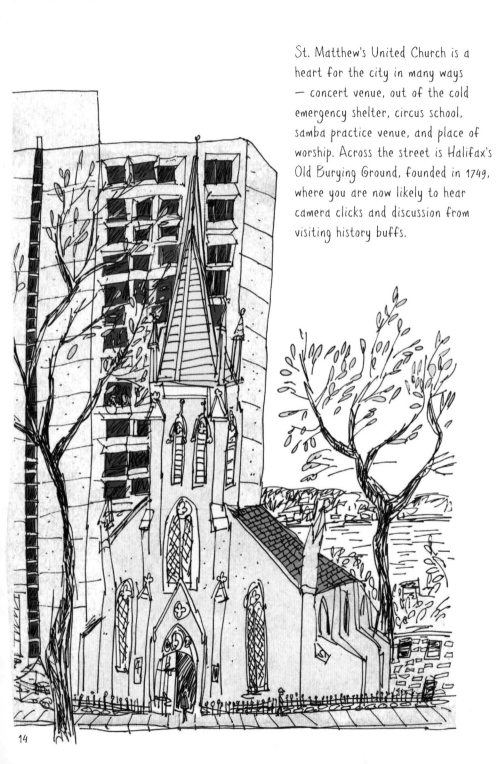

On the waterfront, the rain pours down on the food shacks selling chocolate-covered bacon, BeaverTails and oysters, with no customers in sight. On the sea, a crew of IWK staff doing a team-building exercise in a rowboat head back to shore, while the hatches are battened down on the *Silva*. A lone passerby watching me draw in the rain says: "So would you say you have an obsession or something?"

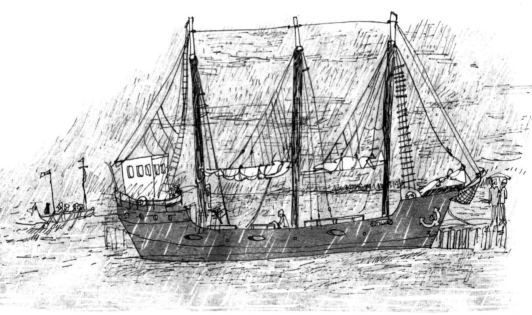

THE CITADEL, THE HARBOUR AND COMMON

In the summer, the Citadel hourly hosts the *Harbour Hopper*, an amphibious vehicle, which loops around the top of the highest point in Halifax before making its descent to the harbour itself. At noon each day a cannon goes off, and the clock tower chimes on the hour.

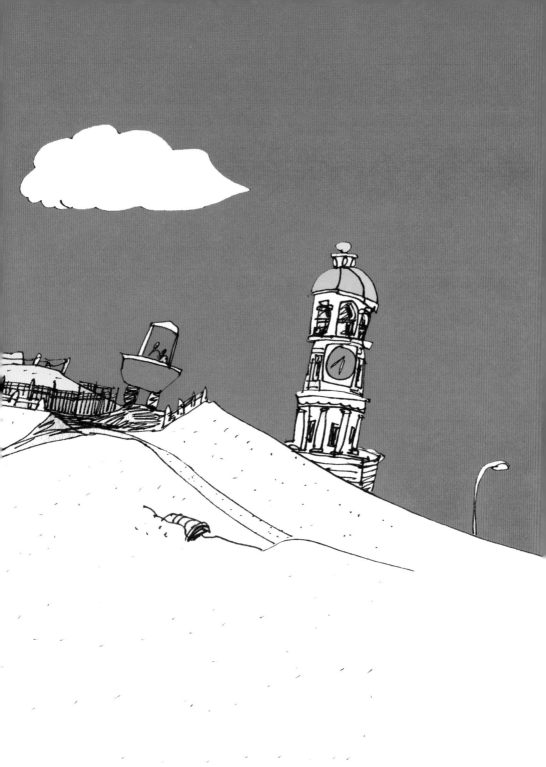

"I used to camp on McNabs during the late '80s.
Remember stopping at this teahouse for lemonade.
Best lemonade ever! They gave me their recipe."
— Scott MacNeill

McNabs Lemonade
Rind & juice of 6 lemons
2 oz citric acid
1 oz tartaric acid
1 tsp Epsom salts
8 cups sugar

Put ingredients in a bowl and pour 8 cups of boiling
water on them. Stir well. When cold, put in bottles.
Use like syrup.

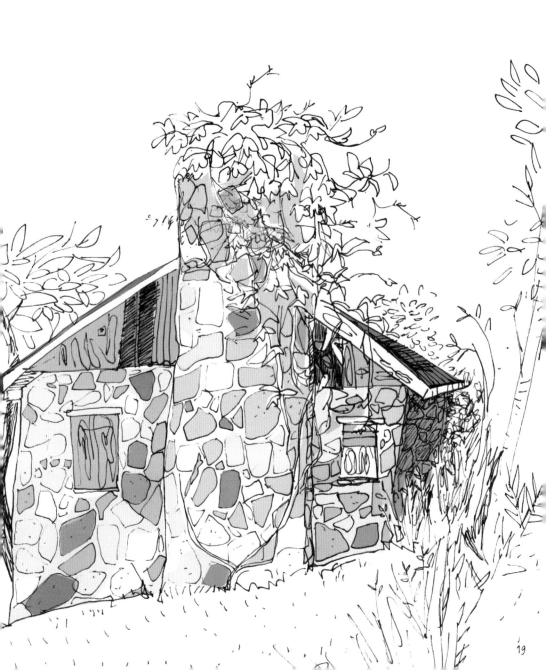

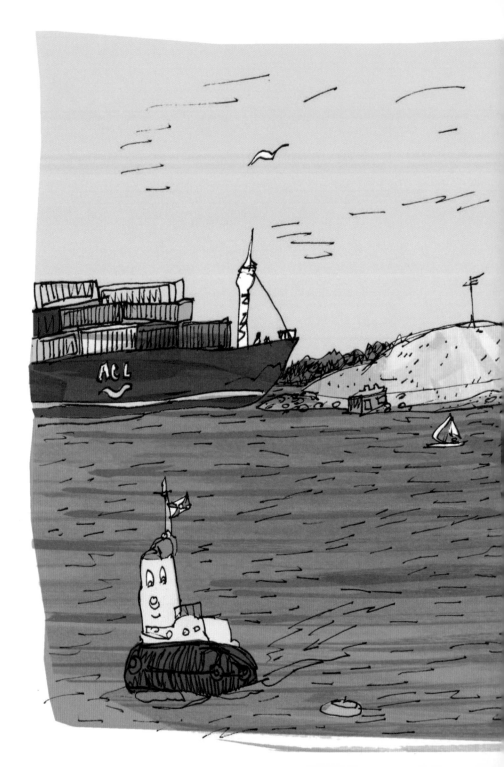

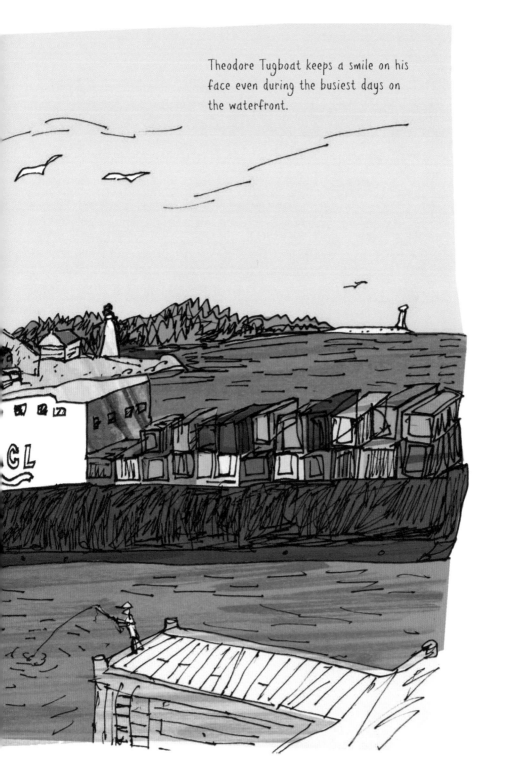

Theodore Tugboat keeps a smile on his face even during the busiest days on the waterfront.

Common Roots Urban Farm, just five minutes
from the heart of downtown, has become
a natural extension of the green space of
the adjacent Halifax Common. Though not
technically part of the park, it is a closer
cousin to the original Common, which was used
as grazing land for cows.

Late in the season, the vegetables have been
harvested and brightly coloured flowers are the
last ones standing, a cheering sight from the
emergency entrance of the Queen Elizabeth II
Hospital.

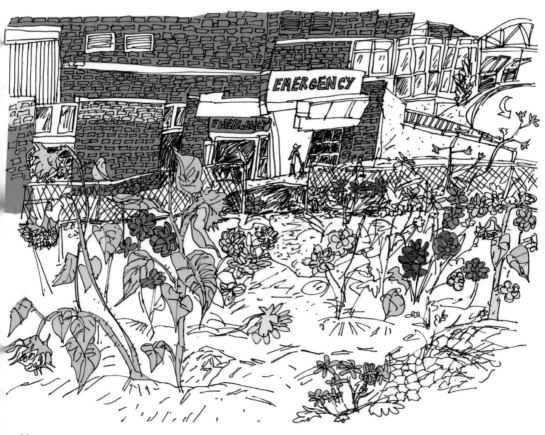

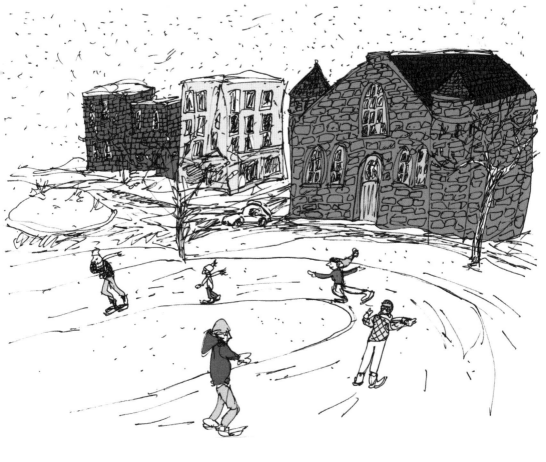

Within sight of the Armoury, the Oval is a popular winter destination. During the day, skating happens in counter-clockwise rotation around the Oval. Complimentary skates are provided, and music blares from speakers. But if you have your own skates you can come at night and skate clockwise, and it is just you and the sound of snowflakes, or maybe a pick-up game of hockey.

SOUTH END

This house on Inglis Street was the home of Chogyam Trungpa Rinpoche, who brought Shambhala Buddhism to Halifax and North America at large. It now houses a film business and an architecture business, and I wonder what the walls would say if they could speak.

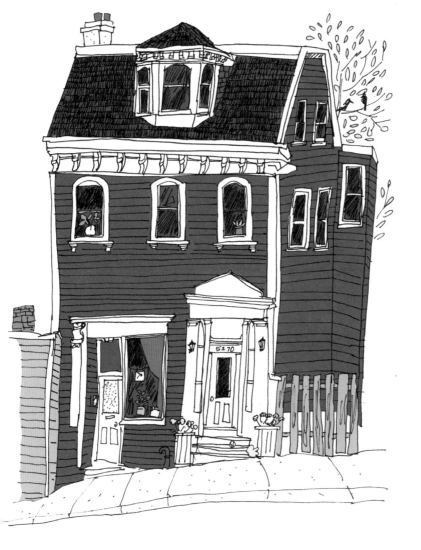

A gentleman who proposed to his wife in the upstairs apartment of this house on Morris Street got in touch with me as he wanted it drawn. He specified wanting tulips in a vase in the left-hand window — as it was his habit to buy tulips and place them there — and a baseball glove on the stoop — as they often went to the nearby park to play catch. A few weeks later, I was approached by another man who had first lived there in 1977, with his sweetheart and now wife, in the same upstairs apartment. He had fond memories of sitting on the stoop, and going to hear live music at Ginger's Tavern, which was then located around the corner. I think it is safe to call it a Love House.

"I love the awesome staff. They want what is best for the pub. It's their baby. Mischief is dealt with easily and quickly, usually with the rest of the pub cheering them out with a: 'This is Resolutes, for goodness sake! Have some respect!' Working behind the bar are your friendly neighbourhood bartenders who just met you and already think you're the cat's meow. Needless to say, I've always been impressed [by] the food. I'll say nothing more than 'brunch' . . . [When I go to a bar] I don't want to worry what I look like . . . I want to get a pint, a pool stick and have some quality time with my friends. This is that place. You need a membership to get in or know someone who does. Want to come off the street and buy one? Sure! Ten dollars, ma'am. Gives you access to free pool, shuffleboard and buckets of good times. But shhhh, some of us are trying to keep this place a secret."
— online review

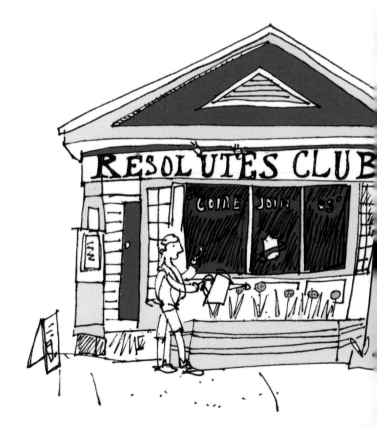

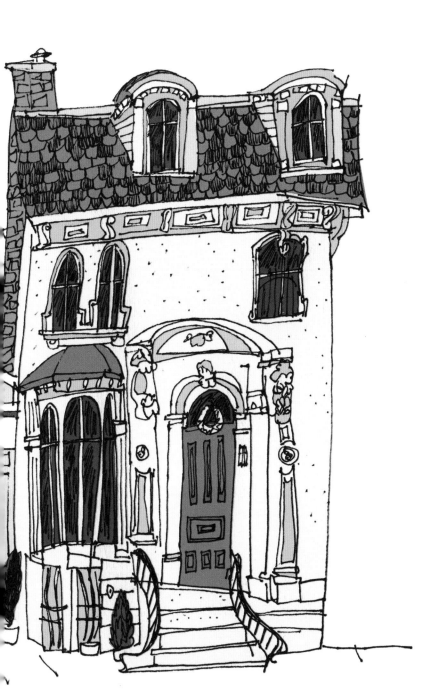

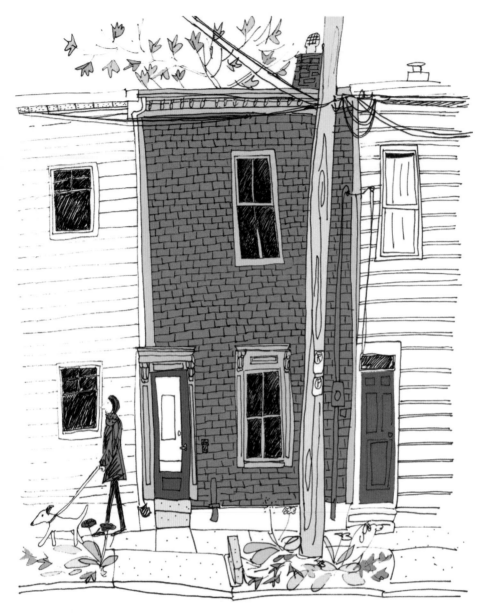

Schmidtville, in the South End, is the oldest and largest contiguous historic district in Halifax, with parts of it built in the eighteenth century. Most of the houses date back to the nineteenth century. It is also convenient walking distance for both dogs and people to Point Pleasant Park.

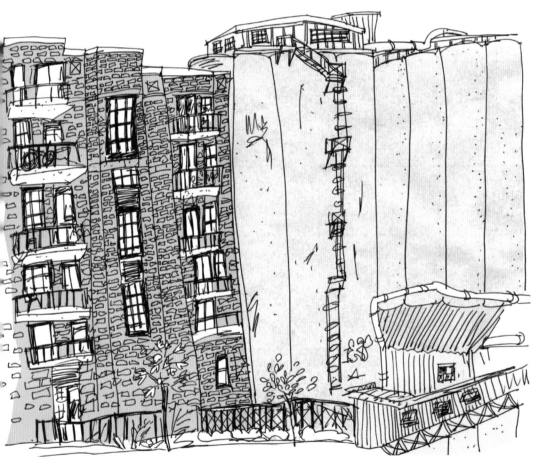

The Halifax Grain Elevator has 365 elevators, and transports corn, wheat, barley and maize worldwide. The Grainery Lofts, a condo building next door, offers luxury living within walking distance of the Halifax waterfront.

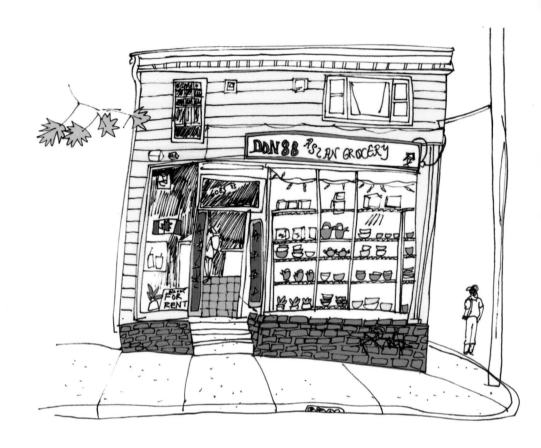

"What are you doing? Why do you like
this place? Do you know the owners? Do
you know the landlord? You should tell the
city about him, he hasn't fixed the roof
properly. What's your name? Oh, Emma,
that is a nice name. I love you!"

When I lived in the South End and passed the Westminster apartment building on the corner of Church and Morris, I used to see an Elvis impersonator hop out of a Smart car and enter the apartment almost daily. At least, I always presumed he was an impersonator.

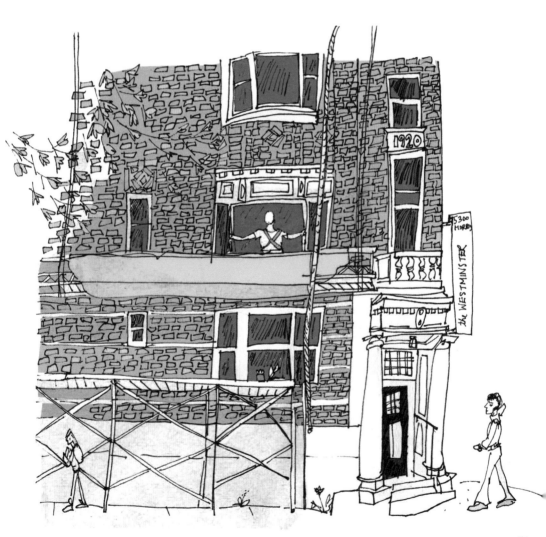

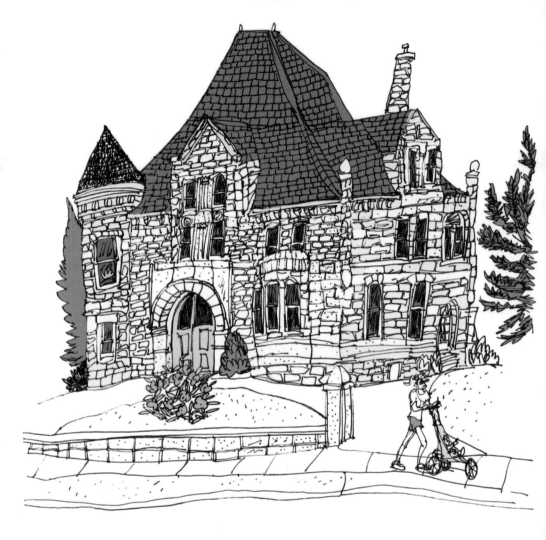

Oland's Castle was built for the Oland family, of Oland's beer fame, in 1890 in the Romanesque Revival style. I wonder if bottles of wine lined their wine cellar, or perhaps just bottles of beer?

Marlborough Park is a small, community-maintained park with access to the Arm. Also boules, a swing and a fine picnic spot. It is a small piece of what was once a fifty-six-acre area called Marlborough Woods.

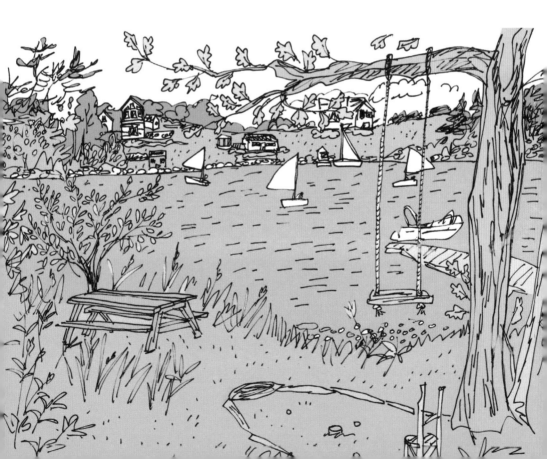

NORTH END

In a pairing that seems as logical as a croissant and coffee or baguette and cheese, Halifax's Alliance Française is located beside Julien's, a French bakery and café, housed in the dignified Hydrostone neighbourhood. Built out of necessity after a French vessel carrying ammunition exploded in the harbour in 1917, the Hydrostone is also close to the current naval base.

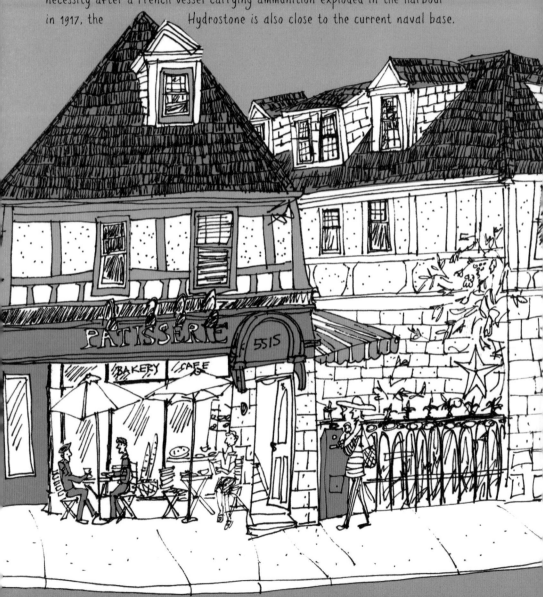

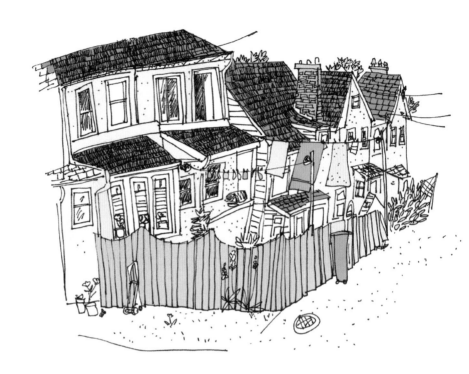

From the front, this Hydrostone home on Hennessey is quiet and reserved, but observed from the back laneway — where radios play on back patios, lawn mowers drone and an amateur musician strums covers of top-twenty hits — it takes on a different persona.

"Originally built as a house in 1845, it has continually been run as a store since 1857. Prior to becoming DeeDee's Ice Cream store, it was run by Pat and Gladys Poirier since the mid '70s. Before that it was a hardware store called Lelekae's. The age of the walk-in coolers that were removed in 2011 tell me that it had been a corner store for many, many years."
— Hal Forbes, neighbourhood carpenter

DeeDee's ice cream flavours
Maple Walnut, Mexican Chocolate, Raspberry Passionfruit Sorbet,
Shaker Lemon, Rhubarb Ginger Sorbet,
Blackcurrant and Lime Sorbet,
Arctic Kiwi Sorbet, Madagascar Vanilla,
Banana Cardamom, Curry Cashew

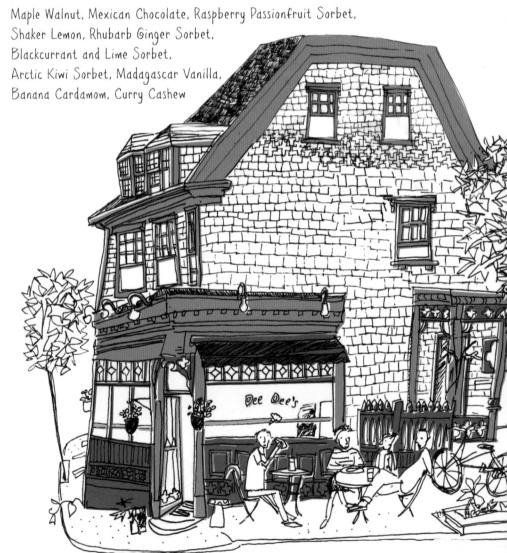

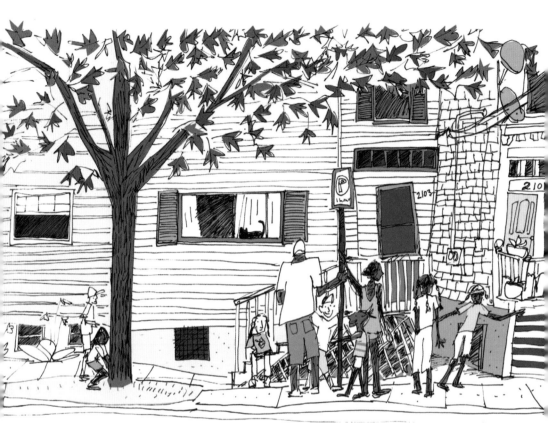

The sound of laughter brought me to Creighton Street. These kids still know how to play; every night, post-supper, they are doing handstands, cartwheels and games on the sidewalk, making maximum use of minimum space. I asked if I could draw them, and they quickly said yes. Unlike most times I draw children, they kept right on playing: a game of tag/ hide-and-seek centred around the parking signpost. It was only when I was done that they came around to ask questions and give their approval. They saw my sketch from yesterday's trip to McNabs and told me all about their camping trip there with youth group. And then they were gone, on scooters and on foot, dispersing into the evening.

Singer-songwriter Laura Smith wrote her version of "My Bonny" in this apartment, a haunting lament that could chill your bones. On a hot summer day, the current occupants make the most of the weather with a wading pool on the sidewalk.

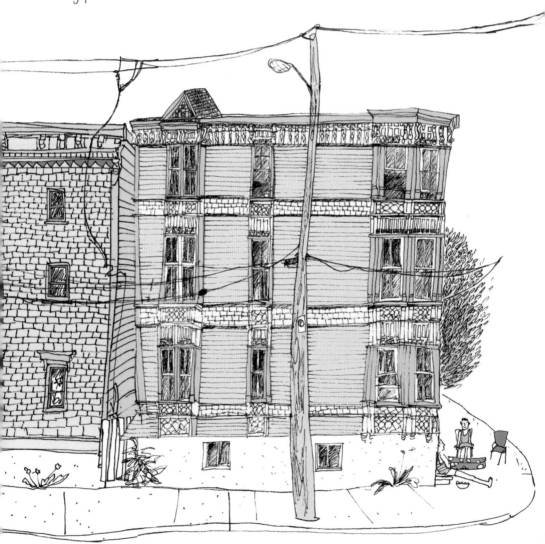

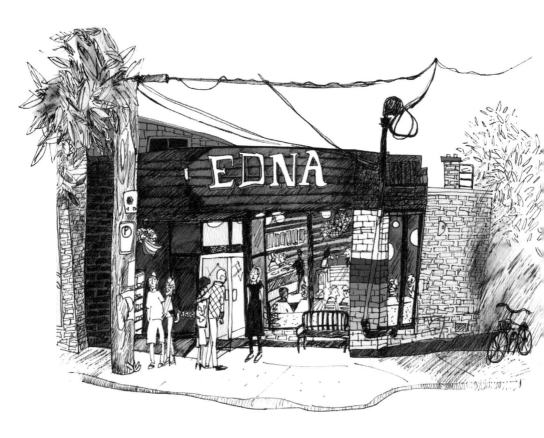

EDNA is a sweet restaurant, and fancy enough to make you feel like a grown-up, just down the block from me on Gottingen. It was opened recently by a friend's sister, Jenna, and is full almost every night. Its decor and spirit is inspired by the poetry of Edna St. Vincent Millay, who wrote:

"My candle burns at both ends; / It will not last the night;
But ah, my foes, and oh, my friends— / It gives a lovely light!"

As I sat on a stool and drew, gentlemen from the Salvation Army a few doors up came to chat. "Oh wow, you can really draw"; "Oh yeah, this restaurant is great; happy to see it doing well." Later Jenna tells me the guys from the Salvation Army will come over and help her lift things at the drop of a hat.

The circus has come to town at the Bus Stop
Theatre on Gottingen Street! Missed your bus? Not
to worry, come in for the show — you might not
want to take the next one once you come inside. At
the very least, let Clare Waqu, the guiding force
behind the theatre (and frequent bartender), pour
you a drink.

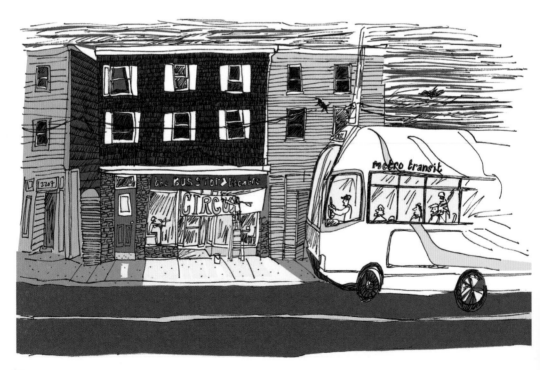

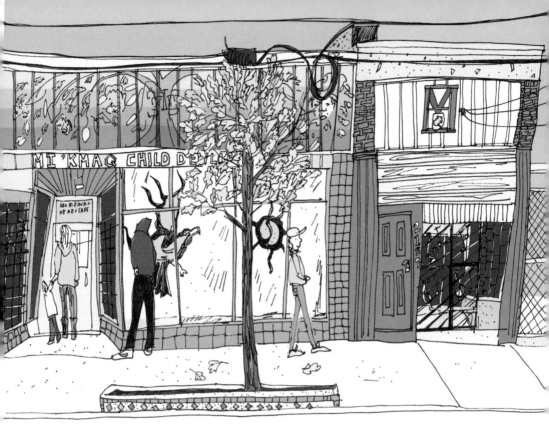

The mural painted on the North End Mi'kmaq
Native Friendship Centre on Gottingen Street is
reflected on the window of the Child Development
Centre across the road, creating an urban anchor
for Mi'kmaq people whose ancestors populated the
peninsula, Dartmouth and beyond.

Two houses flanking Falkland Street were designed by two contemporary Nova Scotian architects, Brian MacKay-Lyons on the left and Niall Savage on the right. The houses respect the rhythm of the street, and their neighbours, while making new architecture.

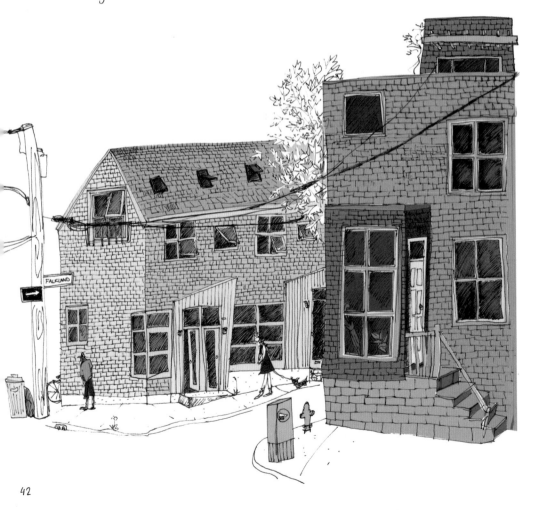

"Oh man, the Creighton Manor. My first summer in Halifax I dumpstered two big bags of fresh corn and ended up eating most of it corn-boil style with about fifteen peeps on the roof of that place. Good times. I also remember a couple of hot, sweaty, awesome dance parties there that I believe were hosted by Caleb and Ian."
— Geoff Tanner

"I covered all the walls in my apartment with orange tarps...for insulation."
— Aaron Daley

"Oh man. That fucking place. I lived in a room that was so small I had to fold up my futon to get in or out, and made my most critically acclaimed record in that place. We stole the Halifax municipal workers' traffic signs and would just throw them up on all four corners whenever we wanted to have a block party. We used to remove the boards from the windows and set up turntables in what was once the store."
— Vaughn Robert Squire, aka Sixtoo

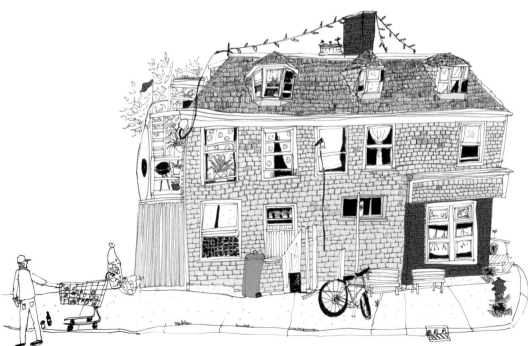

Tomeh's Kwik Way at Maynard and Cornwallis — a corner store with plenty of characters, including Joe Tomeh, who will send me home with overripe bananas for free, with a smile and a nod: "Six bananas, you can make some good banana bread."

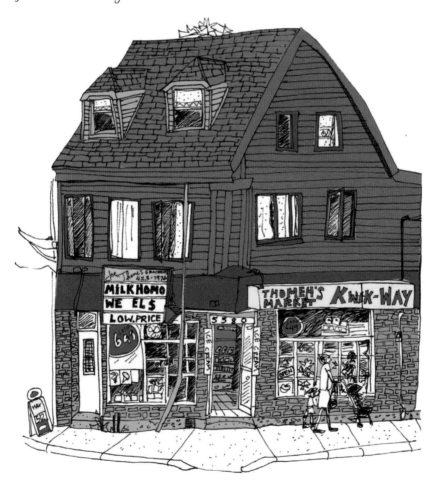

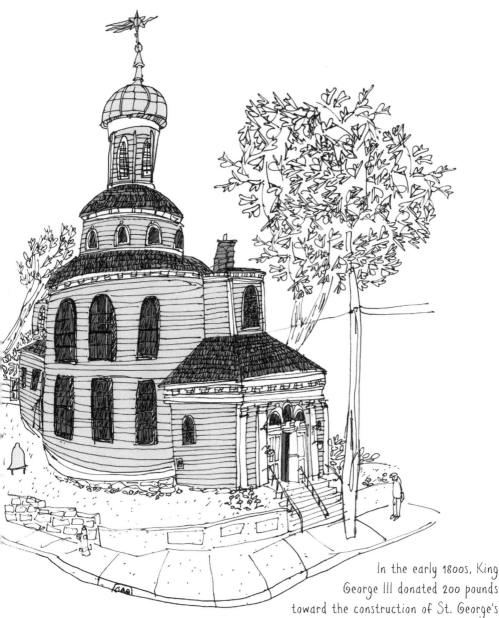

In the early 1800s, King George III donated 200 pounds toward the construction of St. George's Round Church, named for his own namesake. When the church was damaged due to fire in 1994 the royals sent some funds, but not enough to cover the full 4.6 million dollars to restore the church, which was eventually raised by the community. I am at St. George's once a week with kids from the local school, and can say it is a well-used church. At night, it is a special place to hear a concert.

WEST END

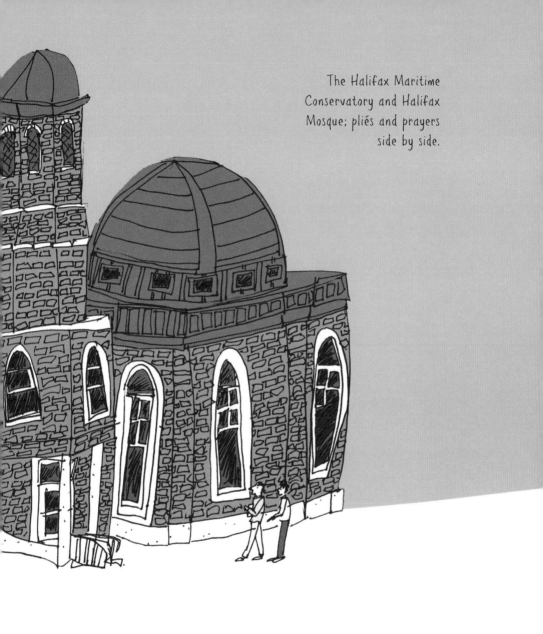

The Halifax Maritime
Conservatory and Halifax
Mosque; pliés and prayers
side by side.

From a woman walking down Quinpool
Road, about Quinpool Shoe Repair:

"Oh Jimmy's fabulous; I bring him all
my shoes; everyone loves Jimmy"

Quinpool Road in September: the university
students have returned and can be spotted at the
Superstores around town, stocking their kitchens
with basic necessities for the semester.

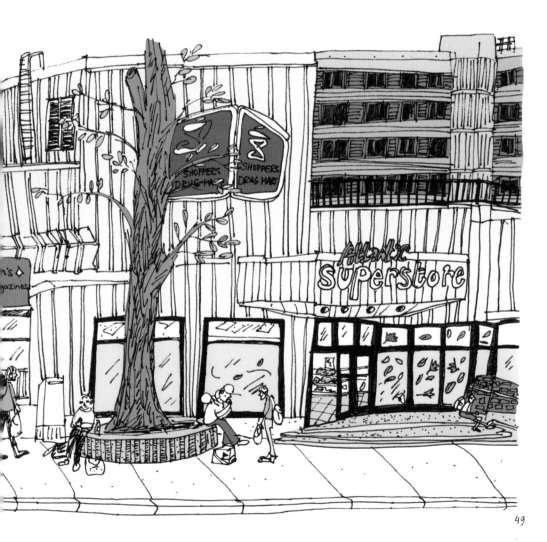

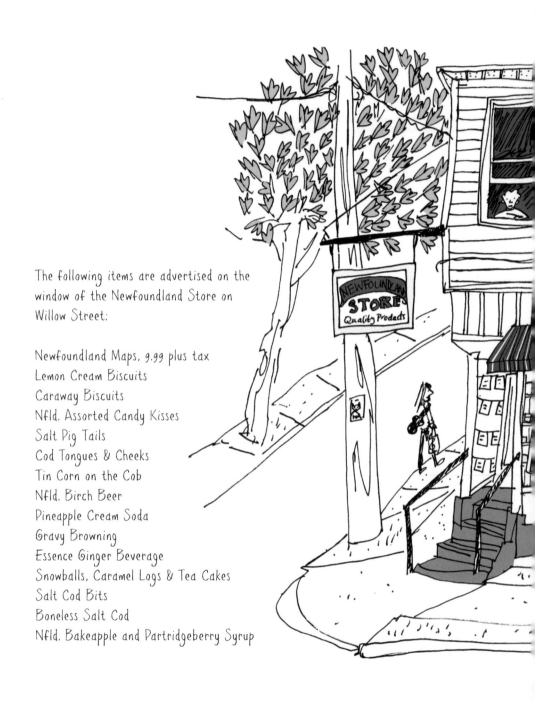

The following items are advertised on the window of the Newfoundland Store on Willow Street:

Newfoundland Maps, 9.99 plus tax
Lemon Cream Biscuits
Caraway Biscuits
Nfld. Assorted Candy Kisses
Salt Pig Tails
Cod Tongues & Cheeks
Tin Corn on the Cob
Nfld. Birch Beer
Pineapple Cream Soda
Gravy Browning
Essence Ginger Beverage
Snowballs, Caramel Logs & Tea Cakes
Salt Cod Bits
Boneless Salt Cod
Nfld. Bakeapple and Partridgeberry Syrup

Chebucto Lane street party and painting; drawn while sitting on a couch in the middle of the street, in front of the Chebucto Lane Luxury Condos.

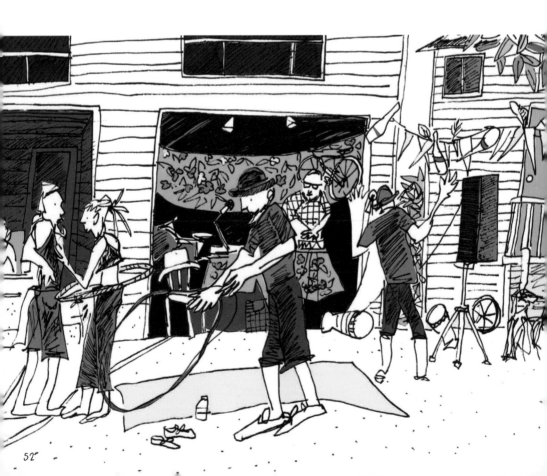

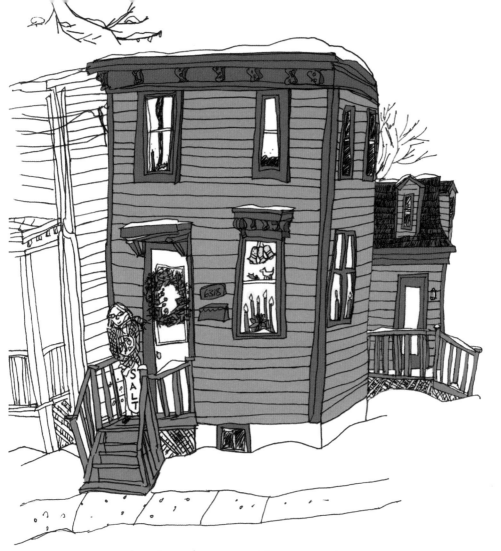

Passing by this bedecked house on Norwood Street, I couldn't help but want to draw it. I asked the woman salting the steps if she would mind if I drew her house, and if she had a pen and paper I could use. Before I knew it Joan Doherty had ushered me into her home, which also happens to be the Marigold Bed & Breakfast. A pot of tea and shortbread appeared, while I took in the many artworks on the wall, most by Joan.

Charlotte, a Dal international student from Beijing, stuck her head around the door; soup was ready in the kitchen. She stays at the B&B during Christmas rather than stay in an empty student dorm. And I could not imagine a more warm and welcoming place.

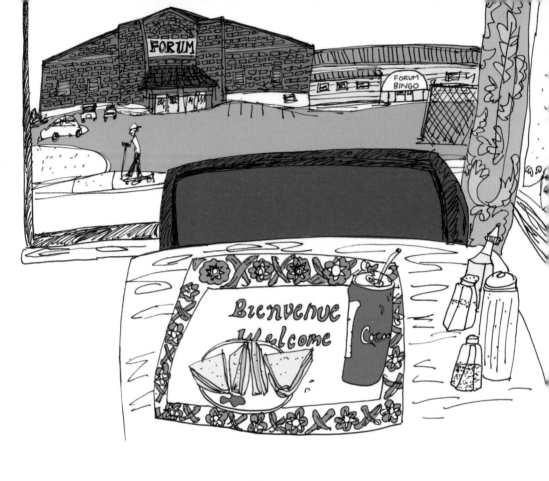

Within view of the Halifax Forum,
Johnny's Snack Bar says welcome
in both French and English, and
the owners are a Greek family.

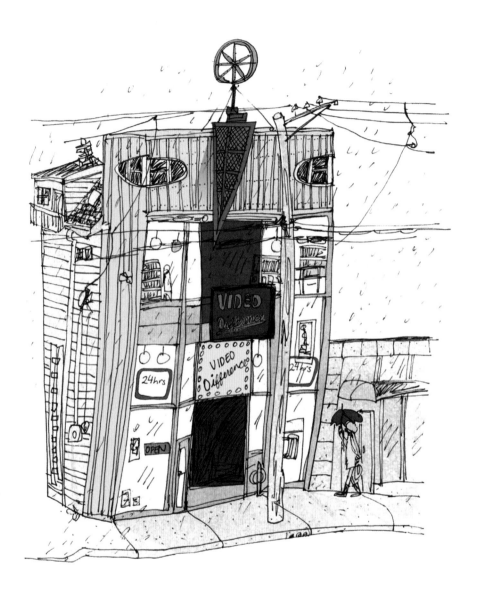

A sure way to test a new relationship: try to agree on a documentary film to rent from Video Difference. It's open late, so you can take your time to decide.

BEDFORD AND SACKVILLE

Overheard at the Chicken Burger:

A man to two boys:
"What do you mean you don't know what
you're going to get?"
"We've never been here before."
"What do you mean you've never been here
before, don't tell me you go to
McDonald's instead?"

A wife and husband:
Husband: "I don't think this
place is so great."
Wife: "Why don't you like it?"
Husband: "I think it is
too familiar."
Wife: "Mary, our neighbour, has
all her birthday parties here."
And they continue eating
in silence.

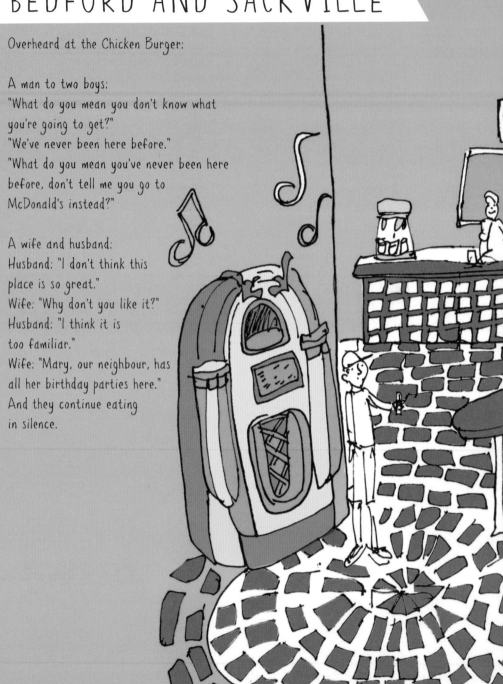

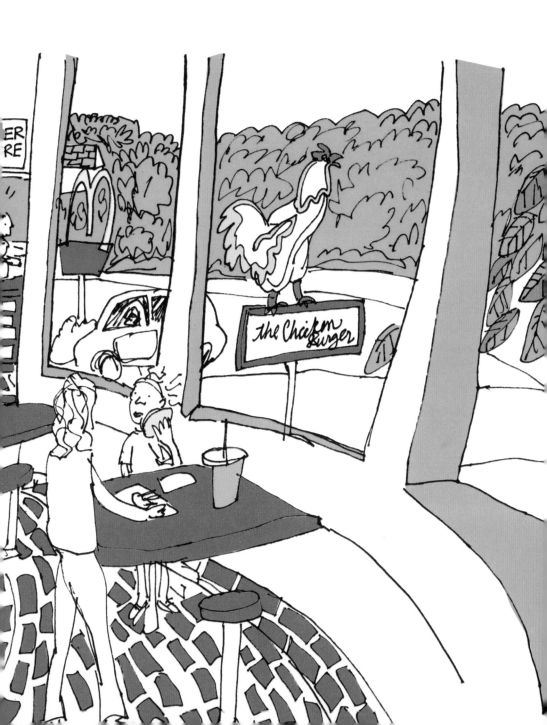

On the Bedford Highway, old houses vie with apartment buildings, all with an enviable view of the basin from their porches and balconies.

Parking lot with a view in Bedford.

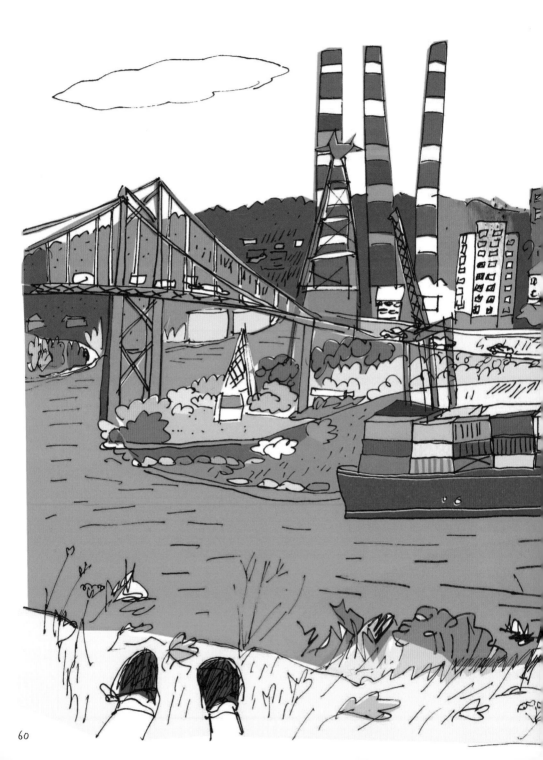

Upon a hill your perspective can change. Above the Bedford Highway, on a hill on Mount Saint Vincent University campus, I drew layers of time and space — the dockyards, the park that was once Africville and the church standing in place as a reminder of the community of houses and people that once surrounded it. Farther still is the MacKay Bridge, apartments where people live, the water tower, and smokestacks beyond.

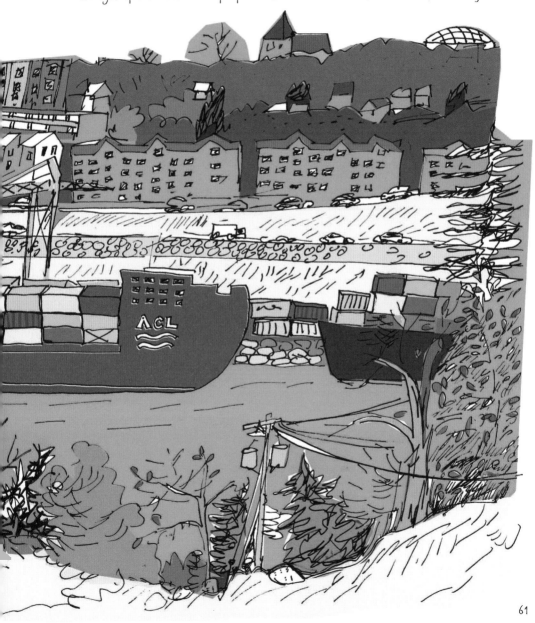

A canvas tent made in 1974 is advertised on Kijiji for forty dollars. A friend gave me a ride out to pick it up. We arranged to meet the tent owner, but got lost. On the phone I said to him:

"I am at the Needs on Sackville Drive."

"Well, there's a few Needs on Sackville Drive. The one by the hair salon?"

"Yes!"

We were in business, and within an hour I was the owner of a once-used-in-1974 tent.

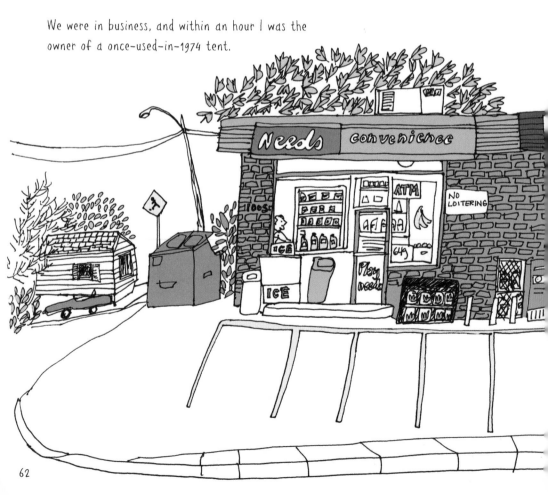

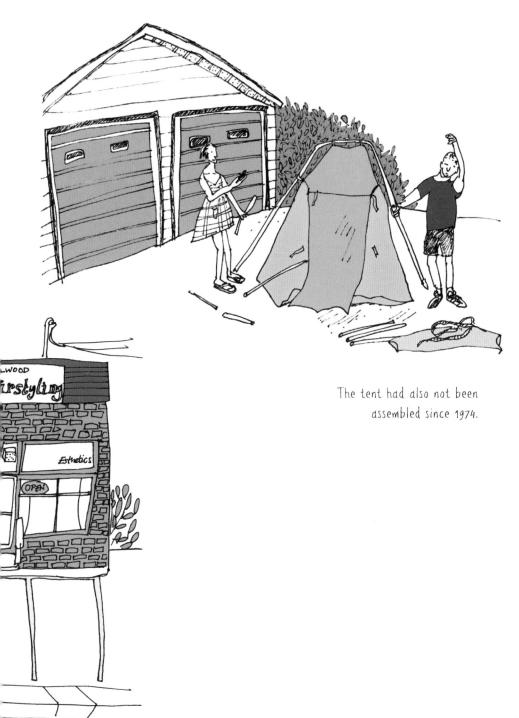

The tent had also not been
assembled since 1974.

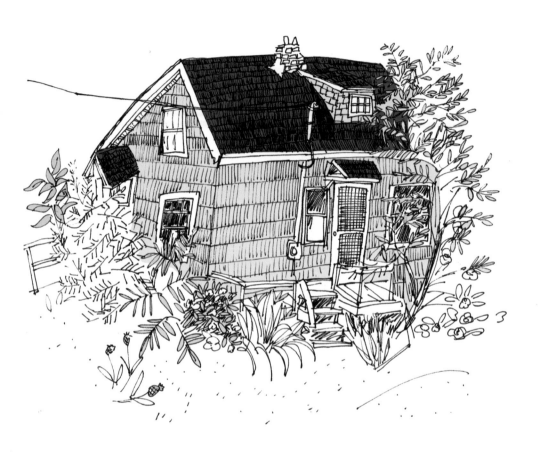

An old house at Connolly Road and Tessa Lane
in Middle Sackville doesn't quite look occupied.
It has a wild garden that would have been well
loved at one time, but now thistles and tiger
lilies hold court as equals in the front yard.

Desperately Seeking Shade
in Lower Sackville.

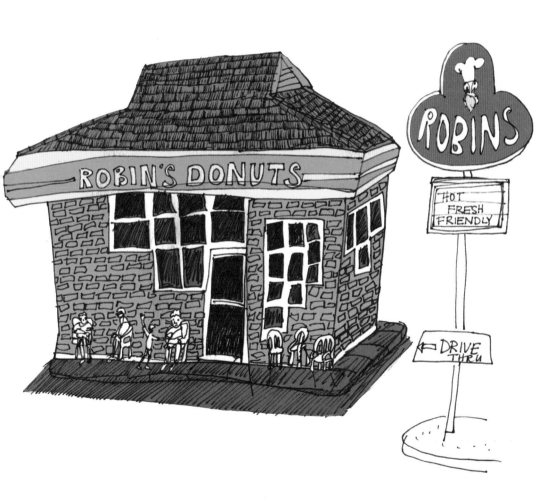

HAMMONDS PLAINS AND ST. MARGARETS BAY

This gentleman played me "Amazing Grace" on the soprano saxophone in honour of Remembrance Day, after I heard him playing from across Hammonds Plains Road. After, he had this to say: "I like to come out and play the saxophone here at different times of day, especially two in the morning; it just sounds different then. If I were in a house downtown I wouldn't be able to go outside and play; I'd be bothering people. Here, no one seems to notice. And the church, St. Gebriel's, across the street, it used to be Anglican, but now the congregation is Ethiopian and boy can they sing. Sing, and dance! But during the day, most of the time, I am wearing earplugs; there are just too many cars on that road these days."

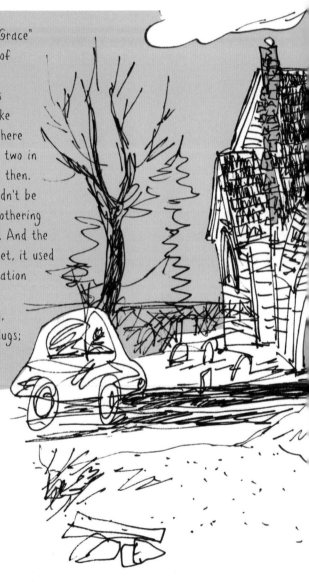

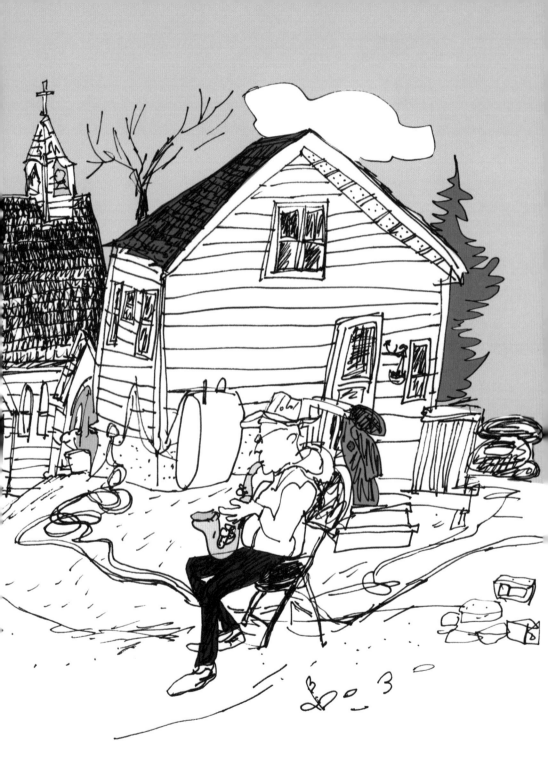

Deirdre in Hammonds Plains: "It's Remembrance Day and maybe too early for Christmas decorations. But we just moved here from St. Catharines and we're missing home, so I think we need a little Christmas. We love Christmas so much we had a Christmas party in July before we left Ontario, with three trees decorated in the backyard...but I only brought one tree with us when we moved here."

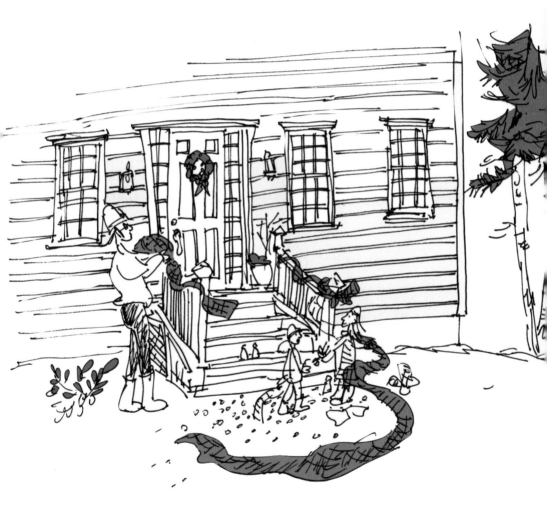

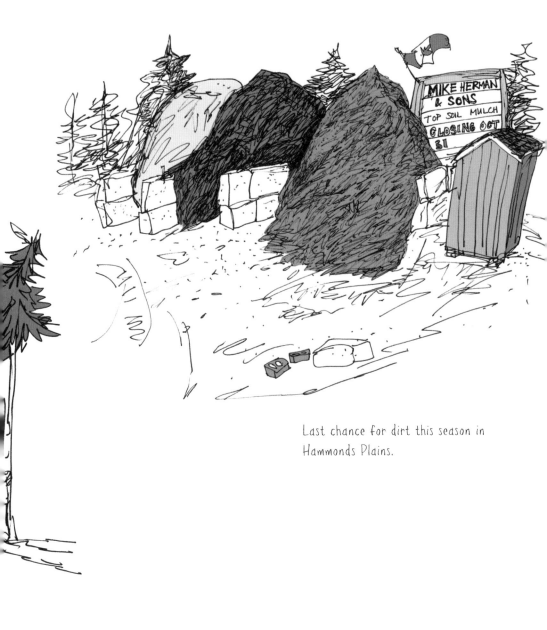

Last chance for dirt this season in
Hammonds Plains.

Playland in Hammonds Plains,
waiting for next summer.

Two crows joy at "Le cottage" on Queensland Beach. It has a floor plan the size of a postage stamp or two, but is a place of joy for its owners.

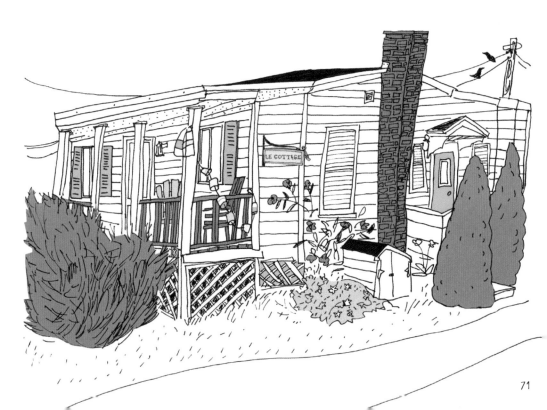

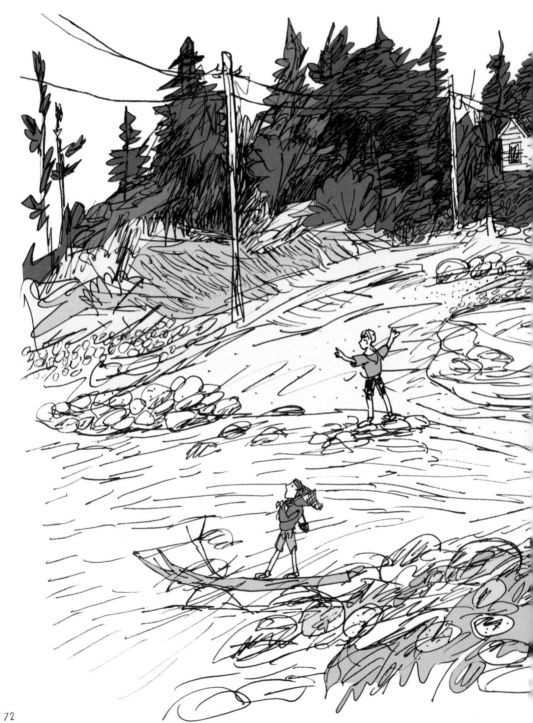

Micou's Island was once a Mi'kmaq fishing ground; arrowheads have been found on the island. For a time it was privately owned, but now is in the trust of the St. Margaret's Bay Stewardship Association. In the summer, the Indian Point Young Naturalist Club takes budding naturalists to the island to learn about its ecology, walking across the sandbar that reveals itself when the tide is right.

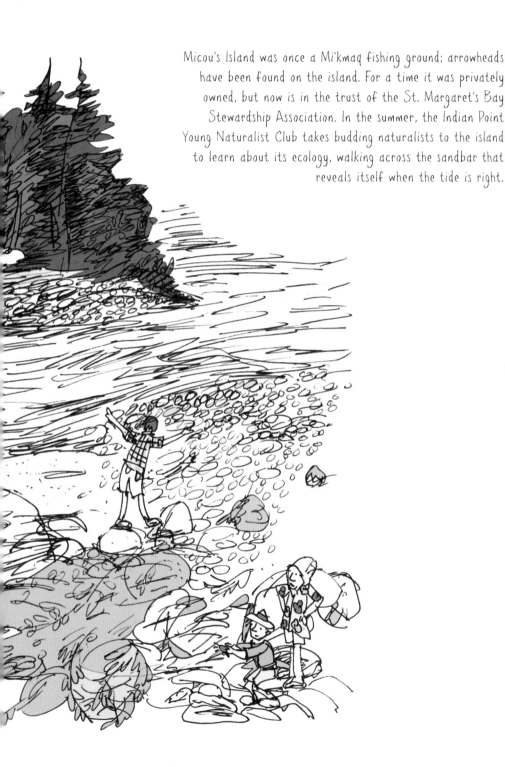

"All you really need is coffee and warm socks" says the Bike & Bean, a welcome treat stop on the bike trail from Halifax to the South Shore. The trail goes all the way to Yarmouth if you're so inclined.

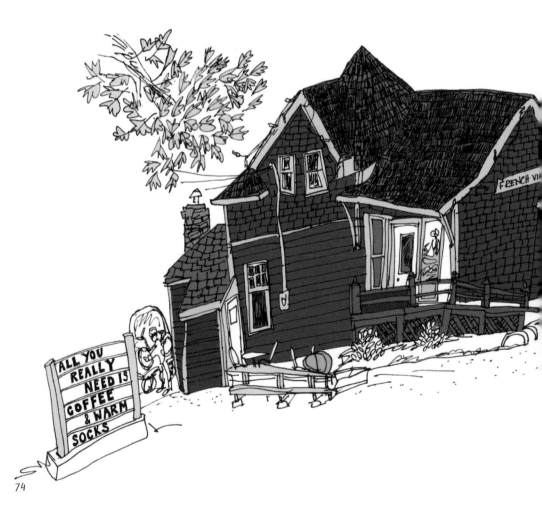

"From here to Hubbards is the best trail yet we've biked in Nova Scotia. Well, I only started biking again in August. I was fifteen years old when I stopped biking, and now I am seventy-two!"

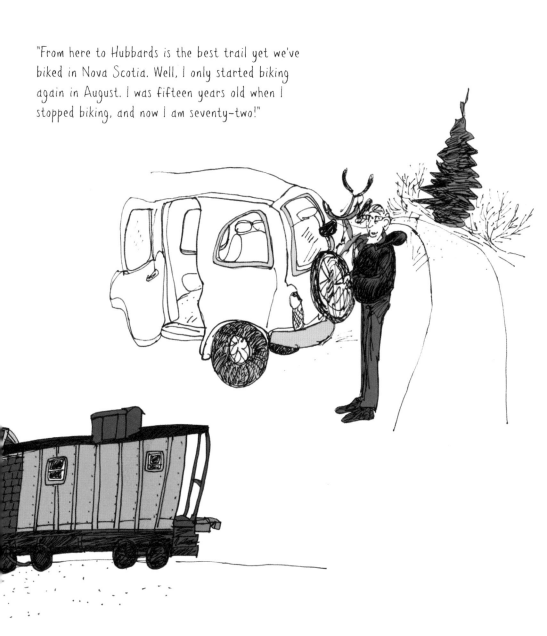

DOWNTOWN DARTMOUTH

When the ferry service from Dartmouth to Halifax
began in 1752, the cost of the ferry was 3 pence
and the service ran from sunrise to sunset, with no
particular schedule. Patrons showed up and were taken
across as needed. In 1816, the ferry was replaced
by a horseboat, employing nine horses walking in a
circle, powering a central paddle. This was replaced
by a steamboat in the 1930s. Though now the MacKay
and Macdonald Bridges are more frequently used
for crossing the Halifax Harbour, the ferry remains
popular with commuters. The upper deck gives a full
panorama of the harbour, including McNabs and
Georges Islands, and the horizon line beyond.

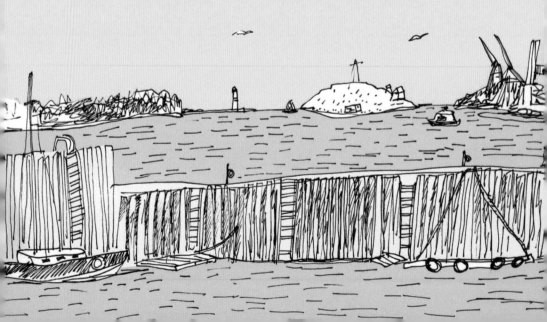

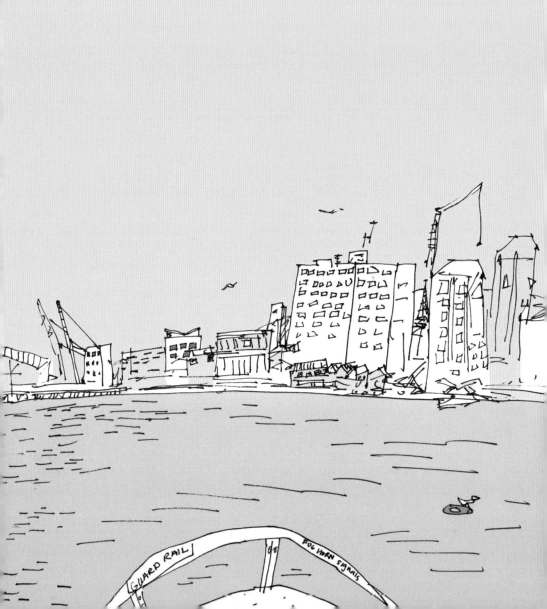

A chestnut tree is in blossom on Pleasant Street.

A woman comes out of her house: "I've been told this is the biggest chestnut tree in Dartmouth."

A man walking by says: "Have you been here at night? Look up in that tree and you'll see a whole family of raccoon eyes staring down at you, it's a classic!"

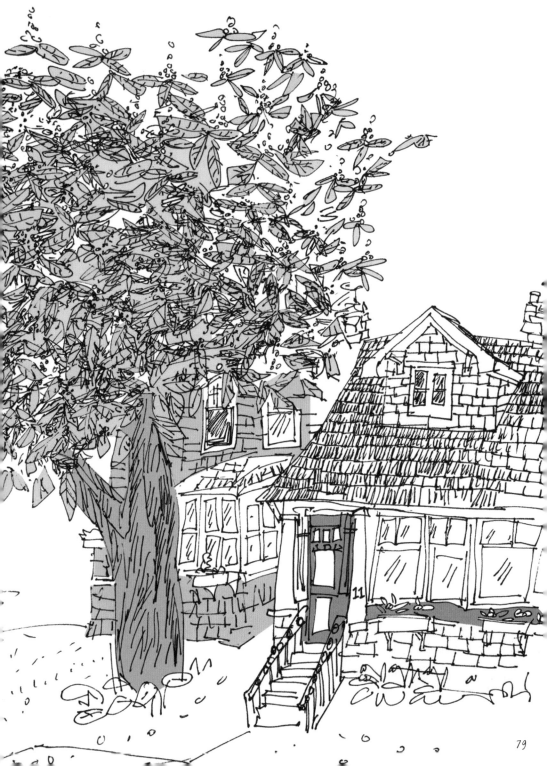

At Two if by Sea, a coffee shop in Dartmouth known for
its croissants, I ask a fellow customer when the café closes.

"I don't know; I don't live in Dartmouth; I don't come here
often. I came over to return a songwriter's notebook; she
left it in a coffee shop in the North End and lives just up
the street. I brought it back to her, I don't mind, I enjoy
taking the ferry."

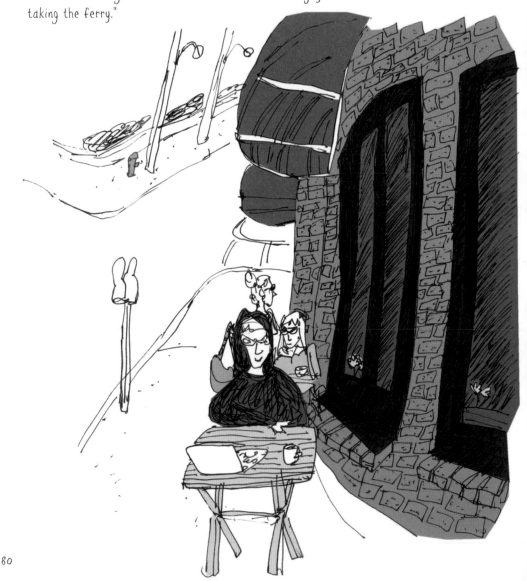

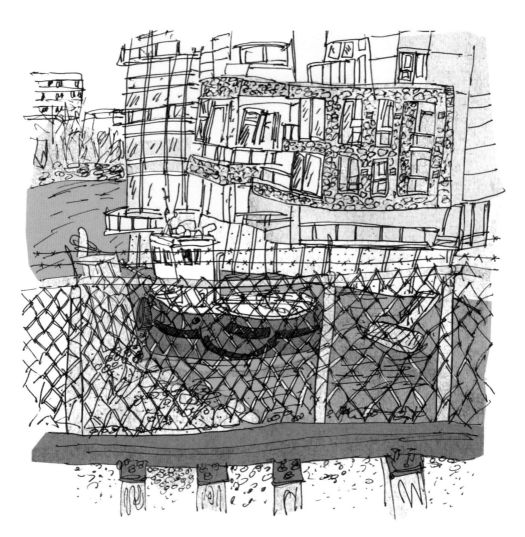

The smell of sunshine on railroad tracks has an unstoppable pull for me, reminding me of hours spent as a child on the same tracks on the other side of the country. It brought me down around by the back of the King's Wharf development in Dartmouth, where the residents have water access from a small dock, sharing space with working boats.

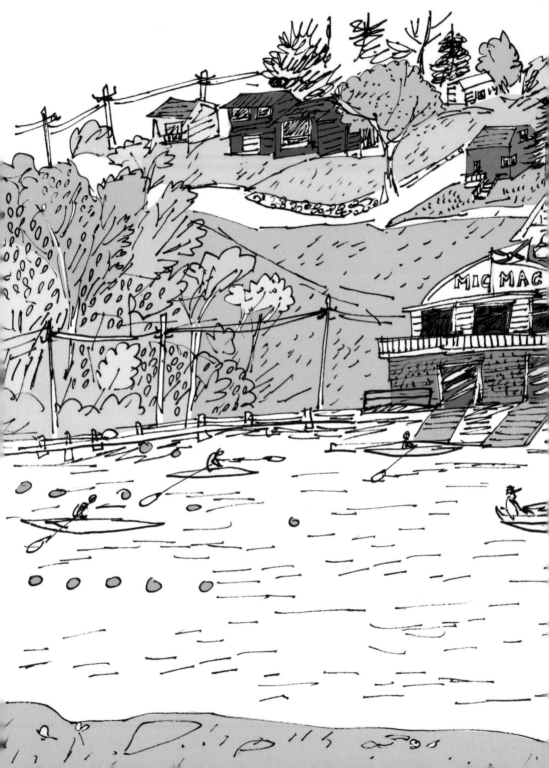

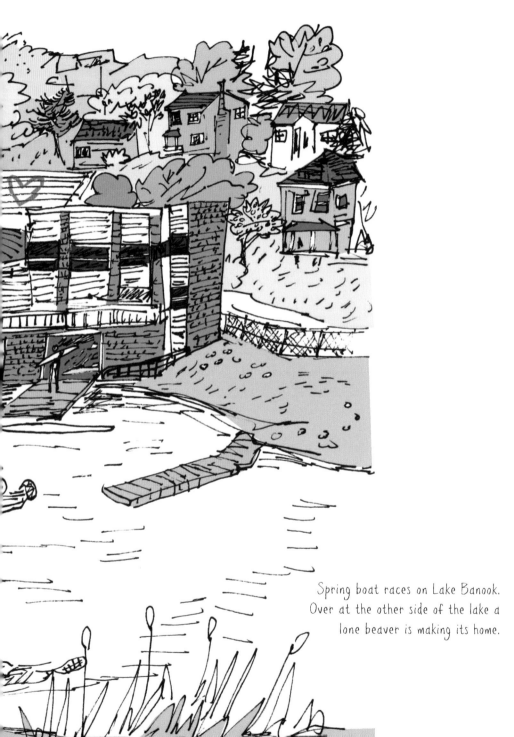

Spring boat races on Lake Banook.
Over at the other side of the lake a
lone beaver is making its home.

It is early spring and the first flowers are all yellow — forsythia, daffodils and coltsfoot. The Leighton Dillman entrance to the Dartmouth Commons beckons, but these apartment dwellers are focused on the garden plots at the base of their building. Many are elderly and have come from more rural places, where their gardens might have been measured in acres.

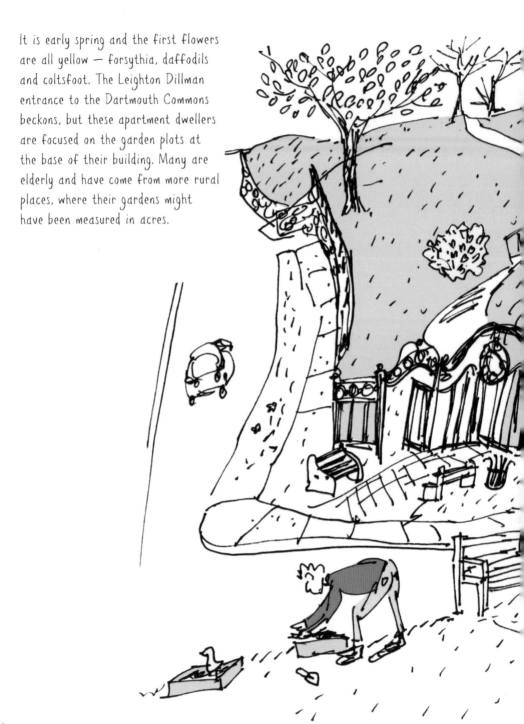

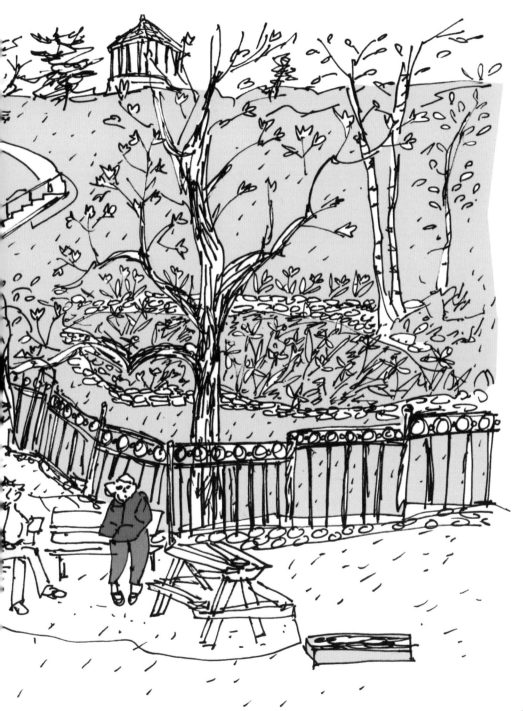

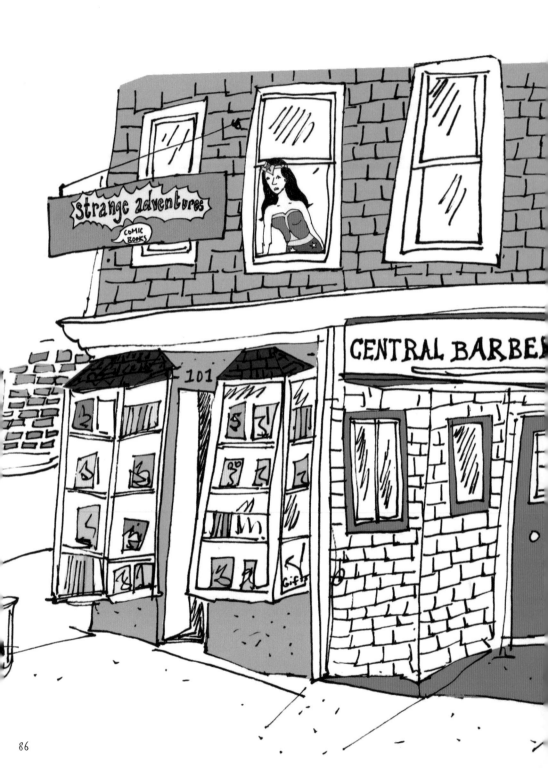

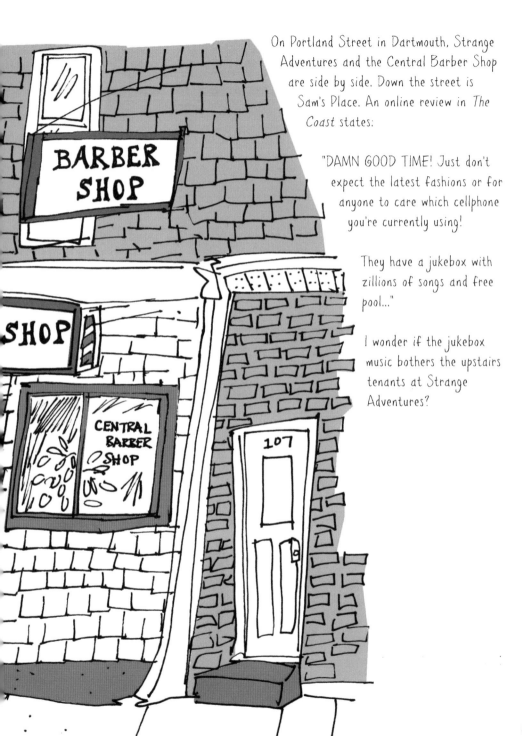

On Portland Street in Dartmouth, Strange Adventures and the Central Barber Shop are side by side. Down the street is Sam's Place. An online review in *The Coast* states:

"DAMN GOOD TIME! Just don't expect the latest fashions or for anyone to care which cellphone you're currently using!

They have a jukebox with zillions of songs and free pool..."

I wonder if the jukebox music bothers the upstairs tenants at Strange Adventures?

CHERRYBROOK, NORTH PRESTON AND PORTERS LAKE

While waiting for the church service to begin at the annual gathering of the African United Baptist Association of Nova Scotia — held this year in Cherrybrook close to neighbouring communities of North and East Preston, and bringing together people from as far away as Alberta — the woman beside me brings out a small plastic bag.

"Would you like a mint? I took them out of the box; they can get so noisy in church..."

I take one.

Later on, the pastor says: "And ask your neighbour, have you been saved?"

The giver of mints, a woman by the name of Lorena, says, with a smile: "Neighbour, have you been saved?"

I say: "It's been a long time since I've been to church."

Another smile and a squeeze of my hand.

"Well, dear, there is no need to rush."

Later, as the church singing moves me to tears, she smiles and holds my hand again, and passes me some Kleenex from her purse.

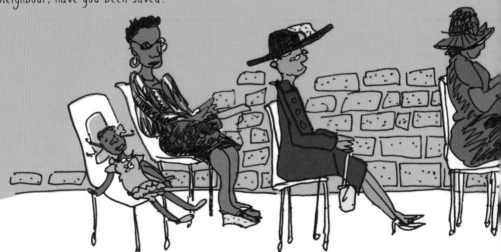

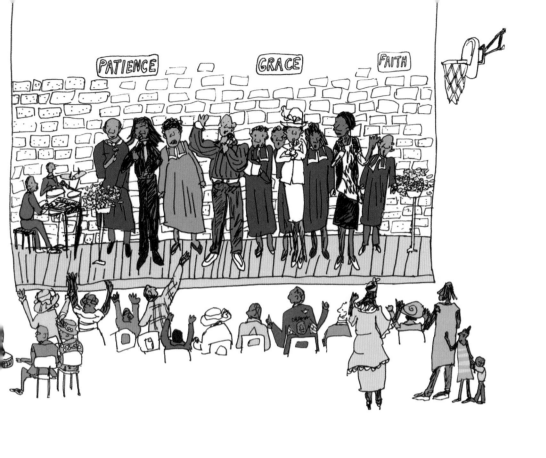

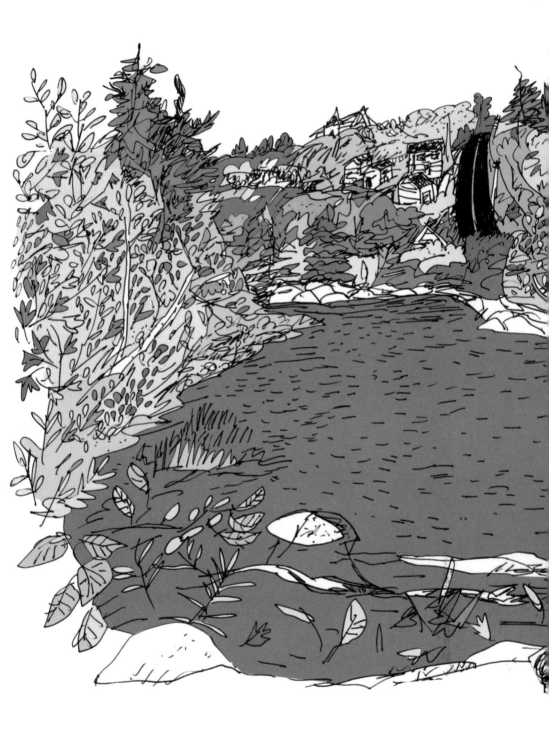

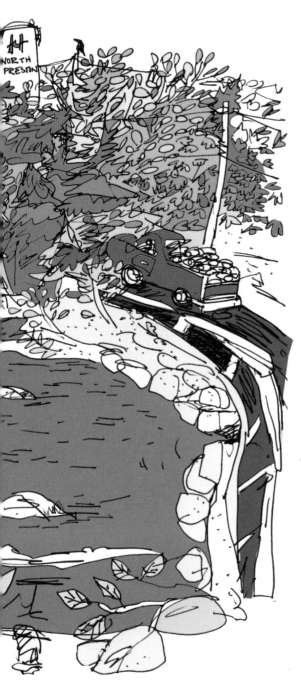

Long Lake in North Preston:
While sitting and drawing by the side
of the road in North Preston, a school
bus driver stops. Surely he must know
I am not a child needing a ride...

"Oh, you're drawing pictures, are you?"
"Yes."
"You want to go up to the bridge
there. You'll get the best view there;
it is beautiful this time of year."

And, he was right: a view
right up the lake.

"What is six plus three?"
"Count your crayons, count your
crayons, and you'll find the answer."
Math gets interactive in an after-
school program in North Preston.

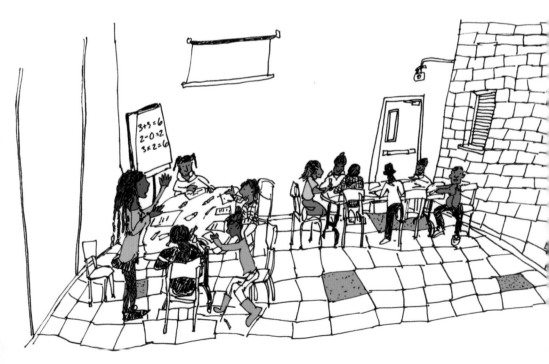

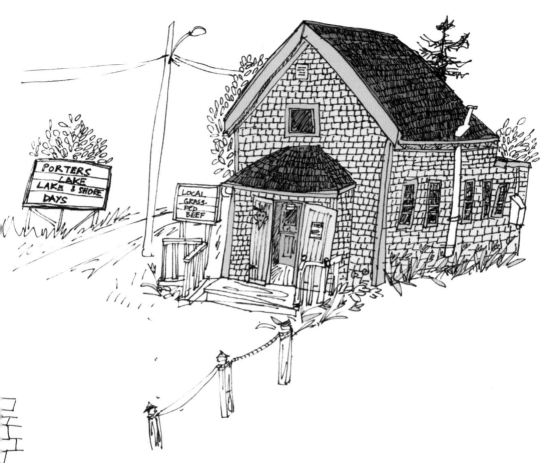

From 1760 onwards, inhabitants of Porters Lake and the greater Chezzetcook area brought goods into market in Halifax as their livelihood. Apparently they sang the following song:

"Do you want to buy the mitt, the sock, the ganzy frock, the juniper post, the mussel or the clam, the blueberry, the smelt, the pelt, the forty foot ladder, the thousand of brick or sand?"

The Little Carrot, a health-food store in Porters Lake, was once the St. Mark's church hall where Hank Snow and other Nova Scotian musicians performed while locals danced.

Mirroring the route that previous inhabitants of Porters Lake would have taken, the Little Carrot's owners also go to the market in Halifax each weekend to sell their wares.

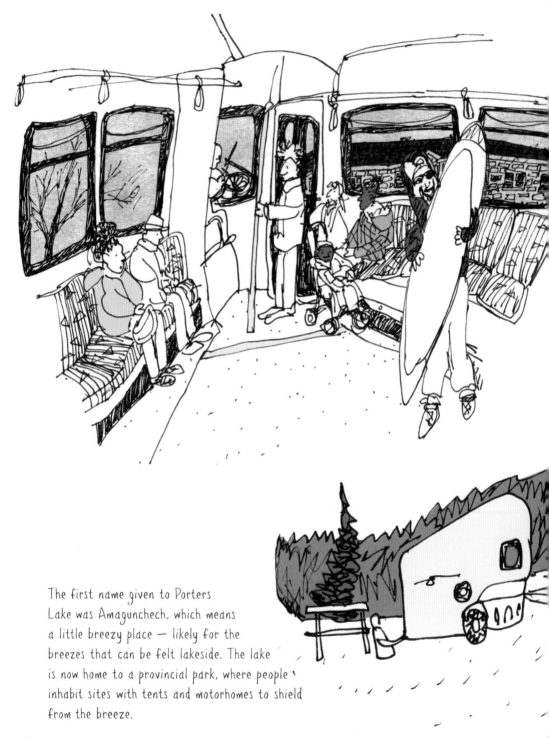

The first name given to Porters
Lake was Amagunchech, which means
a little breezy place — likely for the
breezes that can be felt lakeside. The lake
is now home to a provincial park, where people
inhabit sites with tents and motorhomes to shield
from the breeze.

I was taking the Number 61 bus to North Preston. As we passed Portland Hills, a man got on the bus, a surfboard in his bare hands; the temperature was below zero. "Headed to Lawrencetown, are you?" said the bus driver. "I guess the waves will be nice...won't you be freezing, salt right in your face?" When he left the bus the driver lets him out with, "all right buddy, good luck," and off the surfer went with his board, walking to the waves.

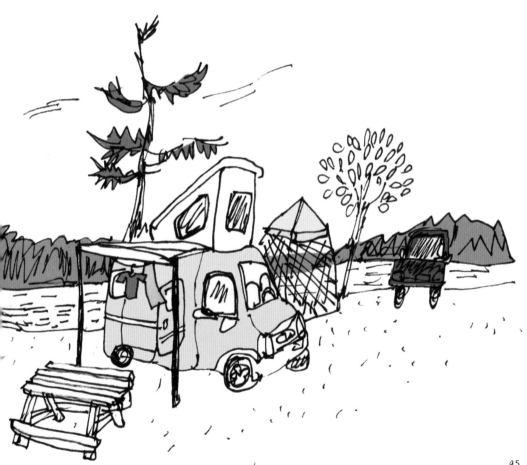

WOODSIDE, COLE HARBOUR, FISHERMAN'S RESERVE, SEAFORTH AND MARTINIQUE

The cleaner at the Woodside ferry terminal is growing a number of plants in the large window, where (sometimes) there is sunshine. Of note were the following: one orange ornamental, one dwarf orange tree, two pixie grapes, McIntosh apple, two lemon trees, a key lime tree, and a Christmas cactus in full blossom.

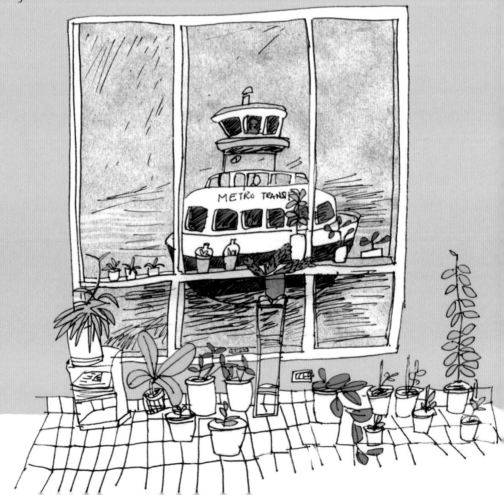

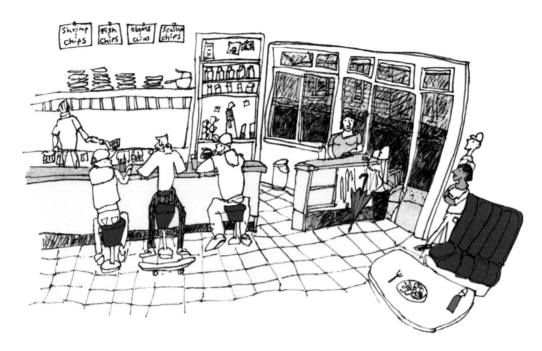

Three NSCC theatre students at John's Lunch, sitting on
stools at the bar and sipping milkshakes:

"So, is it gonna be a play about three guys?"

"Yah, in the round. All of them sitting on chairs."

"What if it was four guys?"

"Nah, has to be three. And lots of general nonsense."

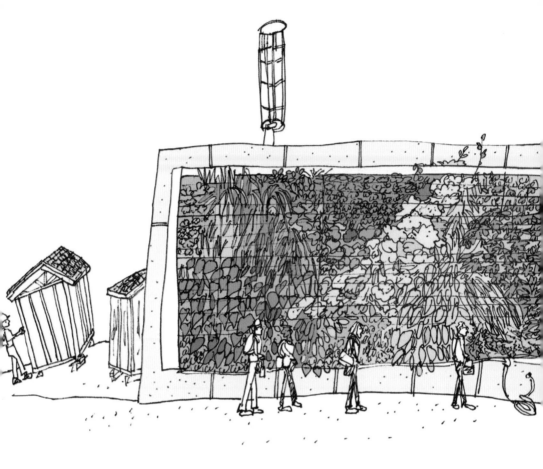

At the Nova Scotia Community College in Woodside, the exterior has a living wall with over seven thousand plants growing on it, creating a large colour field that changes with the seasons.

I thought I was alone with the fog in Fisherman's Reserve, but then along came a woman, who stopped and shared this:

"There used to be a boardwalk here where we'd play, but sure that wasn't yesterday. If the fog lifts my brother will go out and fish halibut tonight, it's lobsters from April through June, and you should come see the colours in the fall. I am from Grand Desert originally, are you biking back there? Sure you'll be there in no time, I used to do it all the time. But like I said, that wasn't yesterday, I live in Halifax now, and haven't biked in years."

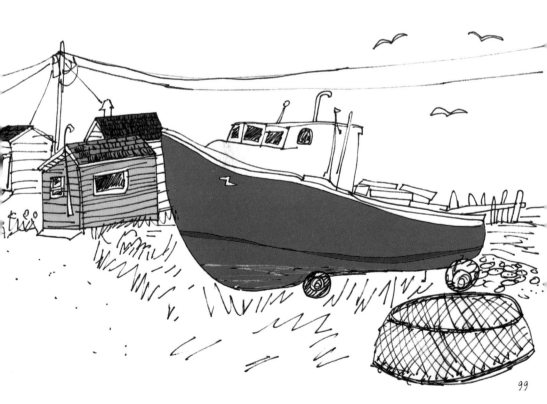

Surfer Joe has been in Seaforth since 1975. The church has been there since 1840.

Joe says to me:

"You want to make sure you get the church in your drawing, and that's Joe Murphy's place over there. I can put a bike in the picture too, let me get my surfboard too, you wanna see this surfboard? I made it myself...

We gotta stop being political, you gotta be in a place and know what it's like. Materialism doesn't have any concern, it's just top-level management that's what it is. They've got the Mexicans picking apples: how are kids here going to learn how to work? I live here, I surf, I pick apples, and in the winter, I go to Costa Rica. Now that's pura vida."

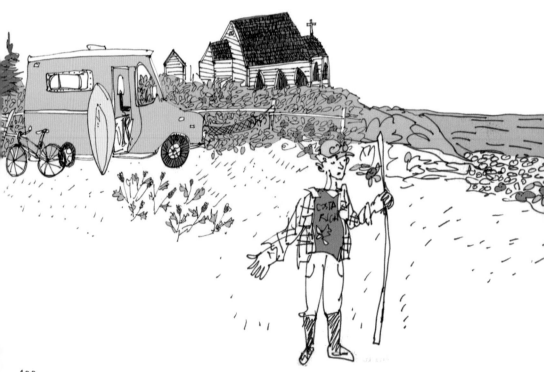

Hope for Wildlife was started by Hope Swinimer, whose first rescue was an injured robin. Now she and an expanded team care for injured and displaced wildlife on her property in Seaforth, and also star in an internationally broadcast TV show about their work.

A peacock, found crying one night in South End Halifax and never claimed, rules the roost in the vegetable garden.

A skunk lost a leg, and will always call the centre home. As a result of his injury he also lost a scent gland, making him easier to visit.

Speaking of visitors, it is visiting hour at the duck pen!

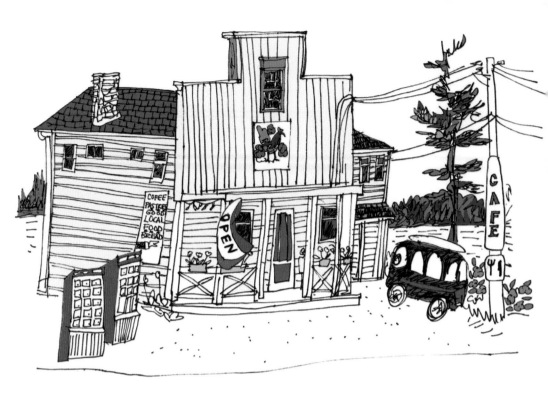

Surfers from the city and locals alike eat
the lemon squares, seedy date squares, lime
cookies, soup of the day and sandwiches at
The Rose & Rooster in Grand Desert.

Red sky at night seems to be a surfer's delight. The moon is on the rise and the sun setting at Martinique Beach.

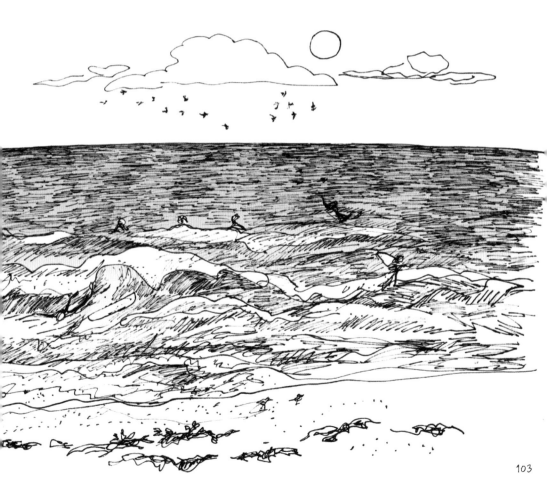

Cole Harbour is famous for being the home of
hockey great Sidney Crosby, but on a cold day
the warm swimming pool at Cole Harbour Place is
a more appealing place to draw than the ice rink
across the hall.

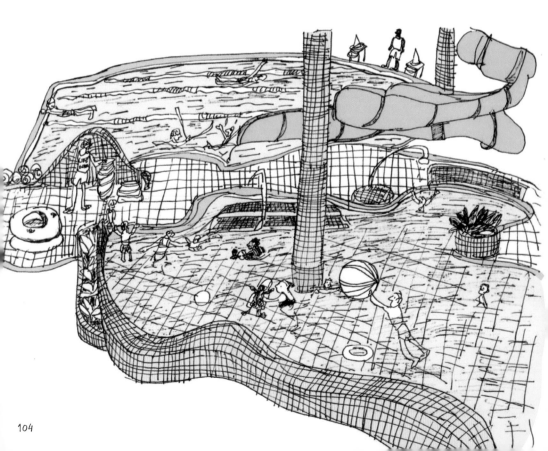

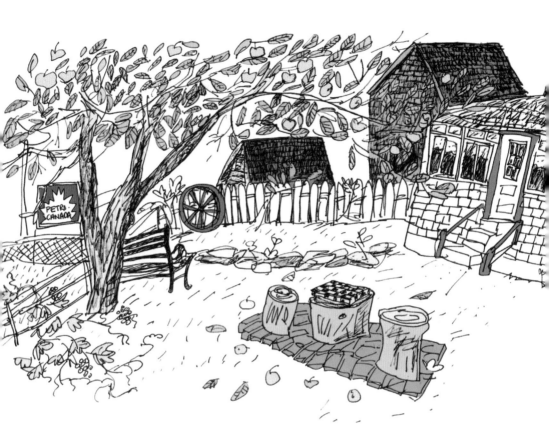

Cole Harbour Heritage Farm sits adjacent to the
Petro-Canada where people fill up with gas, while
a chessboard waits for two players.

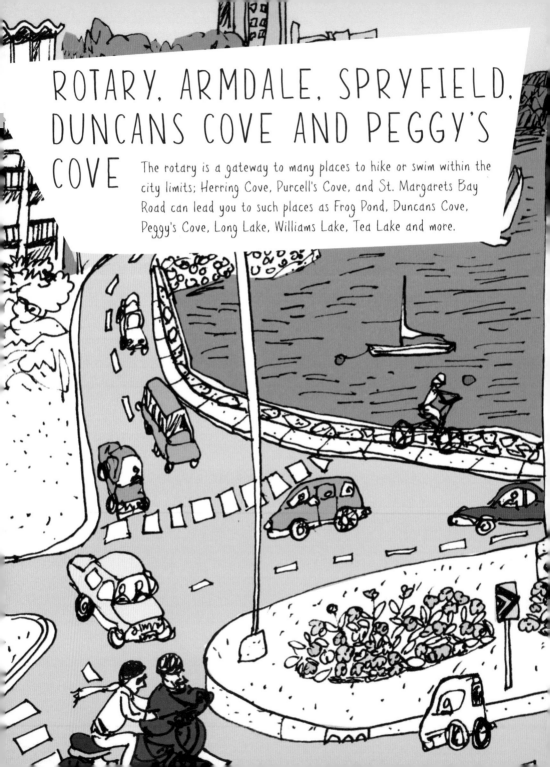

ROTARY, ARMDALE, SPRYFIELD, DUNCANS COVE AND PEGGY'S COVE

The rotary is a gateway to many places to hike or swim within the city limits; Herring Cove, Purcell's Cove, and St. Margarets Bay Road can lead you to such places as Frog Pond, Duncans Cove, Peggy's Cove, Long Lake, Williams Lake, Tea Lake and more.

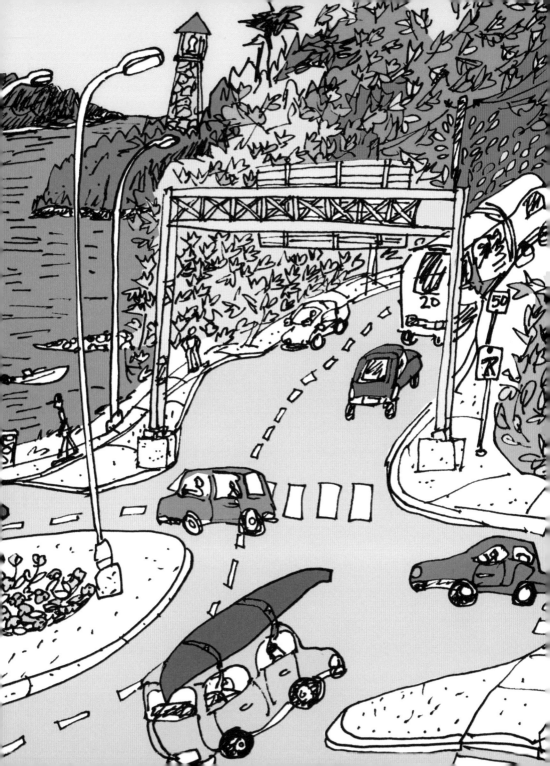

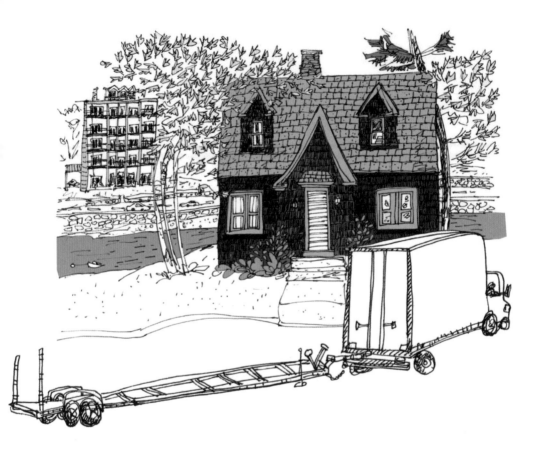

Fall means time to take boats in off the water, like in this cul-de-sac on the Arm.

"I built this fifty years ago, with my own hands,"
says Tom Grove. "It was only fishermen who lived here
before then."

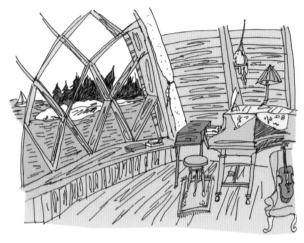

Inside, his wife, Bev, plays violin,
and a lemon tree blossoms in their
sunroom made from salvaged glass
sliding doors.

Tom plays the bassoon; they both
played in the symphony in their day.
Now they make music in their home,
and listen to the music of the waves
in Duncans Cove.

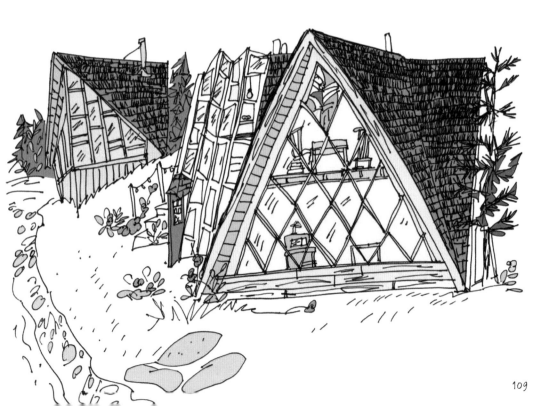

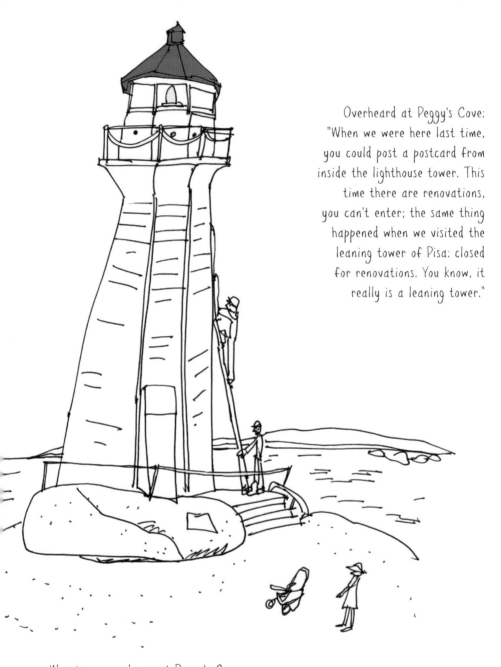

Overheard at Peggy's Cove:
"When we were here last time, you could post a postcard from inside the lighthouse tower. This time there are renovations, you can't enter; the same thing happened when we visited the leaning tower of Pisa: closed for renovations. You know, it really is a leaning tower."

Warning on a plaque at Peggy's Cove:
"Injury & Death have rewarded careless sightseers here.
The ocean & rocks are treacherous. Savour the sea from a distance."

"Aaron, viens, viens avec moi" —
"Aaron, come, come with me," says
a mother in French to her son. But
Aaron is lost in a book, and can't
hear anything or anyone, least of
all the Christmas music playing in
September. The Spryfield Frenchy's
is a treasure trove, like all the
Frenchy's locations that punctuate
the Nova Scotia landscape with
bins of gently used clothes, toys
and, yes, books.

Nova Scotia Hodge-Podge

10 new potatoes, scrubbed, not peeled, cut into small pieces

3 cups chopped new carrots, scrubbed, not peeled, cut into bite-sized pieces

1 cup chopped yellow beans, 1-inch-long pieces

1 cup chopped green beans, 1-inch-long pieces

1 cup shelled pod peas

1 cup cream or half & half

1/4 to 1/2 cup butter

salt and pepper to taste

Fill a large soup pot about halfway with water, and salt lightly (about 1/2 teaspoon of salt). Bring to a boil.

Add the potatoes to the boiling water. Cook for about 7 minutes.

Add the carrots to the pot, and continue cooking for about 5 minutes.

Next add the yellow and green beans to the pot, and continue cooking for about 5 minutes.

Finally, turn down the heat; add the peas, cream and butter, and stir. Let simmer for 3 minutes.

Makes enough for 4 to 6 people.

The original Kidston farm in Spryfield was one thousand acres, and started in 1822, but by the 1960s only seven acres remained in the family name. Now on the same plot of land stands an urban farm, where members of the community can grow food.

On a fine day in September, the Second Chances Band played music to the wind, and volunteers proudly served hodge-podge soup made with vegetables from the farm.

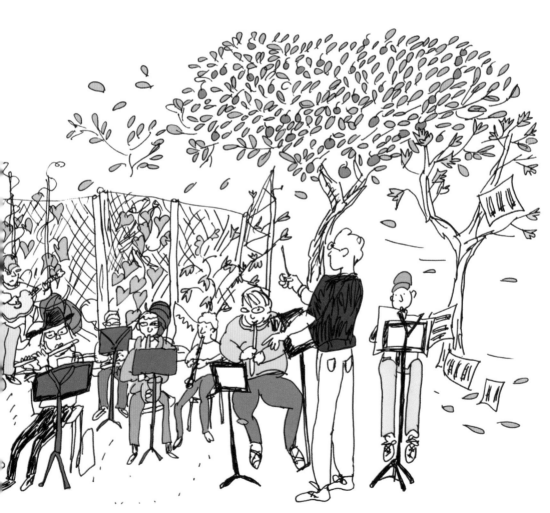

FAIRVIEW, CLAYTON PARK, BAYERS LAKE AND BEYOND

Behind Bayers Lake shopping centre, Susies Lake has a hidden gem of a hiking trail and swimming spot, where there are blueberries for the picking. For those adventurous enough to canoe, it is part of the Birch Cove lakes loop, which includes Cranberry Lake, Big Horseshoe Lake, Three Finger Lake, Crane Lake, Ash Lake, Fox Lake and Quarry Lake.

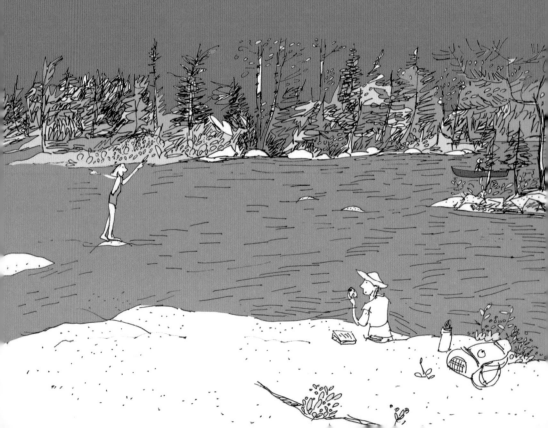

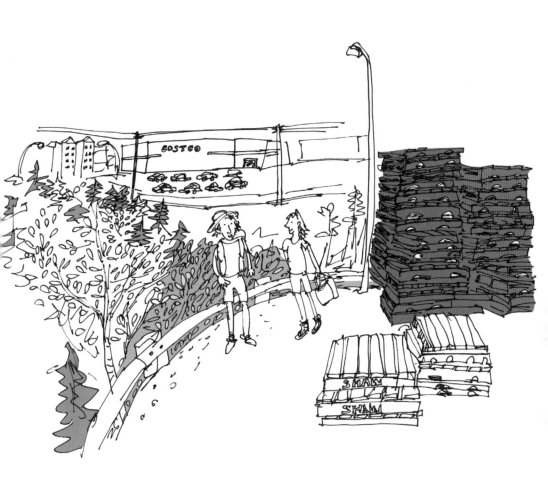

Getting to Susies Lake requires walking through the Kent parking
lot to find the trail, within sight of Costco. The land that buffers
the protected area around the lake is still game for development,
a threat to the area retaining its wildness and rare plant species,
including hosts of pink lady's slipper in spring.

An apartment building in Clayton Park creates a courtyard, maybe even a canyon, the walls making a safe place for play. Voices bounce off the walls, shouting different names: Jessica, Moustaffa, David and Yafatou, in a game of hide-and-seek/ tag. Women wear brightly coloured saris with winter coats and sweaters over top, and rooftop solar panels catch the last of the evening sun rays.

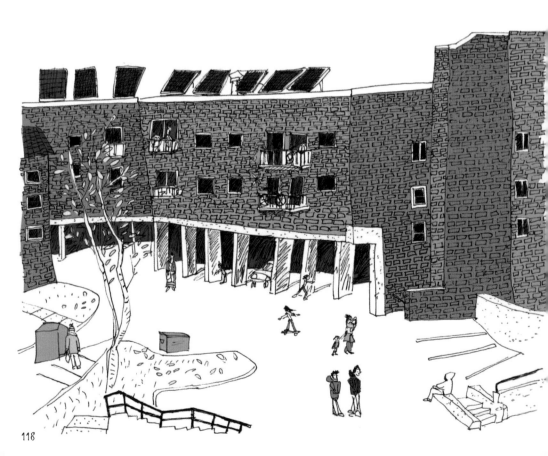

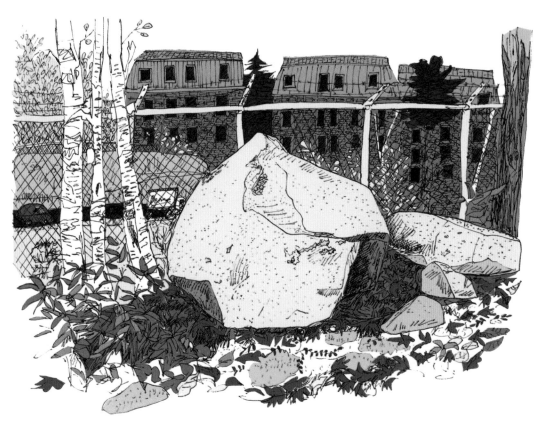

Here is the famed "Ashtray Rock" of Joel Plaskett's album of the same name,
referred to in his rock song "Drunk Teenagers," and located in Northcliffe
Woods in Clayton Park.

Halfway to Ashtray Rock
Spray painted on a cliff
I hate Clayton Park
I want giant spliff
I want to leave my mark
Out in the wilderness
I need to take a piss

Drunk teenagers, let's
start a fight
Out getting wasted on a
Saturday night
Drunk teenagers, you can

pick your poison
The city or the country
We just wanna make
some noise
Oh yeah!

I don't wanna get no
sicker
I just wanna get real
gone
I know we can find some
liquor
at the Bayers Road

Shopping Mall
Dave Boyd says he knows
a dude
They call him Johnny
Hook Me Up
I know he could hook
us up

Drunk teenagers, let's
start a fight
Out getting hammered on
a Saturday night
Drunk teenagers, you can

pick your poison
The city or the country
We just wanna make
some noise
Oh yeah!

— Written by
Joel Plaskett

119

"My grandfather, Elmer Naugler, had a hand in the design of the initial Clayton Park houses, despite having no formal education. He emphasized the importance of *carports* and included one in every house design. He was thinking of families coming home and needing cover as they brought groceries inside, and children needing places to play that were covered during bad weather and close to the house. He also made sure there were double sinks in the houses, realizing the impracticalities of having just one sink when he would do dishes with my grandmother in the evenings, something they always enjoyed doing together." — Allison Sparling

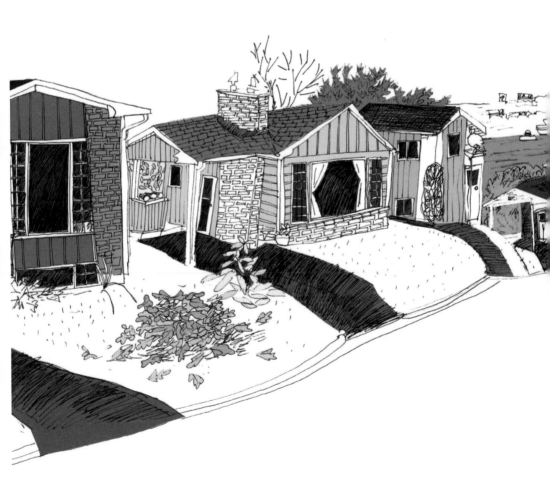

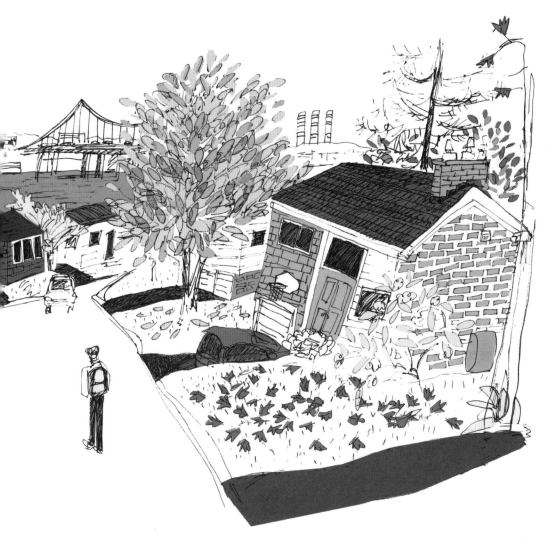

Glen Garden, on Glenforest Drive, is an initiative to bring together new immigrant families and longtime residents in Clayton Park. I saw the initial installation of the garden — a sudden and surprising flash of people wearing reds and golds and bright pinks, from Kurdistan and Afghanistan, digging into new soil. Kids running around with Spiderman face paint, and lots of hope. The water for the garden comes from the apartments across the street — a donation of Killam Properties. Almost two years into the project, there are now forty-nine families involved. The weather has changed, and the beds have been put to rest for the season, but the sunflowers still stand taller than the bus stop.

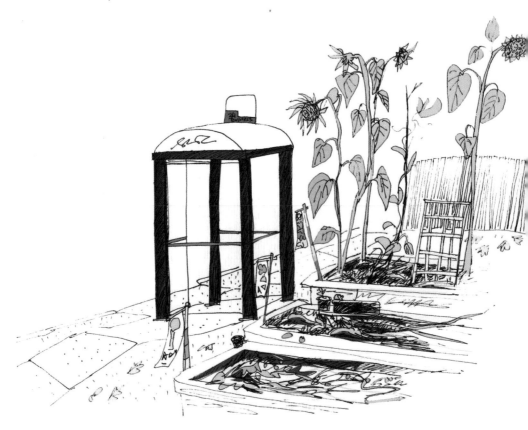

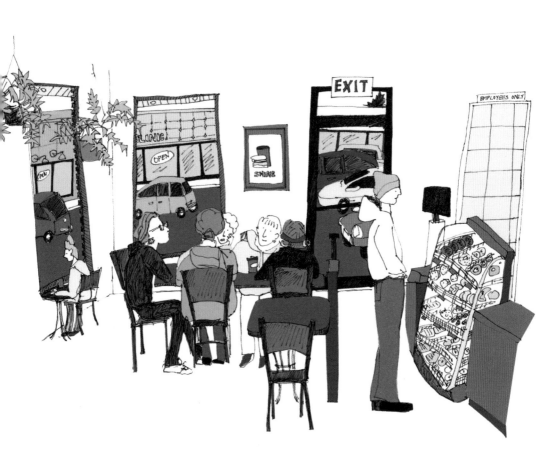

Today I had to concede defeat to the weather, which is now below zero.
I went to Clayton Park, and drew inside the Tim Hortons, surrounded on
all sides by parking lot. Inside, ladies who lunch over soup and bagels kept
on their coats as they ate. A teenage couple also kept on their coats, but
the girlfriend tells her boyfriend he'd better get ready for winter camping.
At the Tim Hortons everyone is united in their quest to get warm, and it
doesn't feel so bad that our days above zero are numbered.

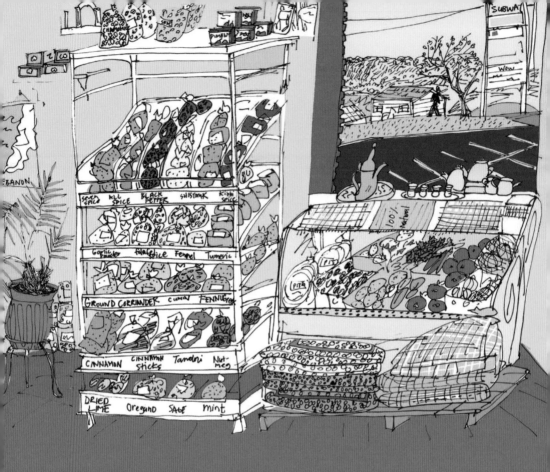

Sounds of Arabic and smells of spice at the Al-Arz Market and Pita
Bakery on Alma Crescent; I go to the till with tomatoes, chickpeas, a lemon,
an onion and a bag of cloves. "Ah," the woman behind the counter nods with
a knowing look. "You are going to make soup." And, indeed, I was.

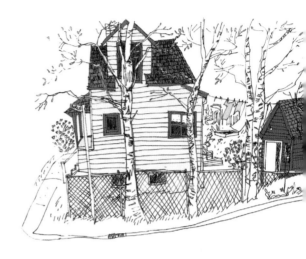

"Whatcha drawing? ...Oh, I see."

Ten minutes later he comes out of his white house on the corner of Maple Street. "Here is a book on the neighbourhood. You know where I live; just bring it back to me in a few months."

In the book I don't find the answer to my question that led me to the drawing. I was wondering what came first, the large maple tree about to burst into leaf on the corner of Maple Street or the street name, and likewise for the row of birch trees on Birch Street.

However, I do find out Fairview is friendly.

The Christmas tree industry in Nova Scotia is worth $30 million per year. Though the most famous Nova Scotian Christmas tree goes to Boston each year, locals can buy trees on corners such as this one.

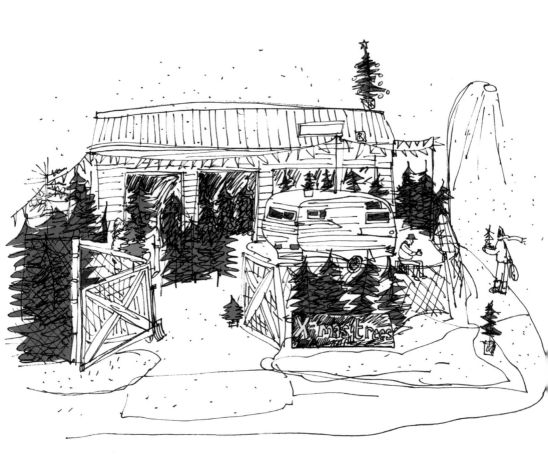

Super Mike's Convenience Store in Fairview, not to be confused with Super Mike's Convenience Store 2, also in Fairview.

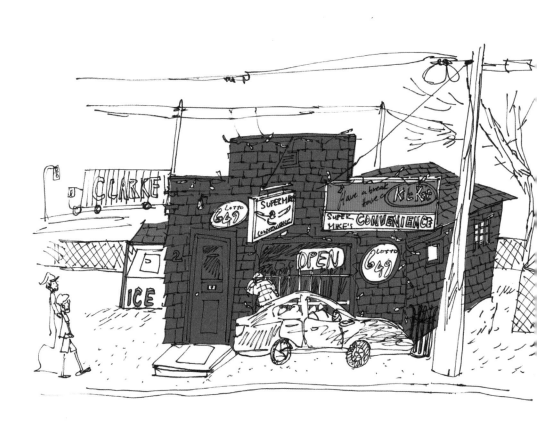

ACKNOWLEDGEMENTS

I would like to sincerely thank Meghan Collins, Jim Lorimer and everyone at Formac Publishing for believing in this book.

Thanks to the people of Halifax who breathe life into the city.

Thanks is due to the Maritime landscapes, both natural and human made, that have endeared themselves to me.

Thanks to the many people who helped with this project, in ways big and small. They include dear friends, mentors and strangers. There are too many to mention!

Finally, a huge thank you to my parents, Trish and Mark, my sister Laura and my brothers David and Jeff. They have encouraged me in my creative life in ways beyond measure.

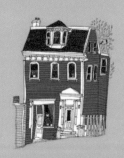
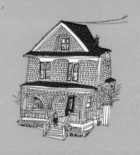
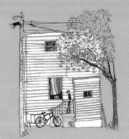
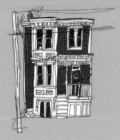
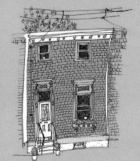
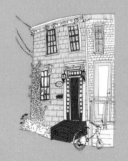
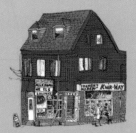
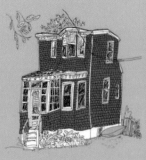
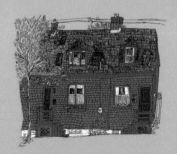
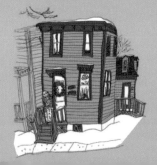